SSED•ART•THOU

NG•WOMEN. ST LUK

The Art of Stained Glass

The Art of Stained Glass

Church Windows
in Northeast Pennsylvania

EDITED BY

RICHARD W. ROUSSEAU, S.J.

SCRANTON: THE UNIVERSITY OF SCRANTON PRESS

Library of Congress Cataloging-in-Publication Data

The art of stained glass : historic church windows in northeastern Pennsylvania / edited by Richard W. Rousseau.

 p. cm.

 ISBN 1-58966-007-2

 1. Pennsylvania--Church history. 2. Glass painting and staining--Pennsylvania. I. Rousseau, Richard W.

BR555.P4 A78 2002
748.59148'3--dc21

2002075207

Cover and book design by Trinka Ravaioli Pettinato, Grapevine Design.
Window photography by Guy Cali Associates.

Scriptural passages are from
The New Revised Standard Version Bible: New Revised Standard Version Bible
Copyright © 1989, Division of Christian Education of the National Council of the Churches of Christ in the United States of America. All Rights Reserved
Reprinted with permission from the publisher.

Distribution:

The University of Scranton Press
Linden & Monroe Avenue
Scranton, PA 18510
Phone: 1-800-941-3081
Fax: 1-800-941-8804

PRINTED IN CHINA
by Sun Fung Offset Binding Co., Ltd.

CONTENTS

PREFACE

RICHARD W. ROUSSEAU, S.J.

EDITOR

When the new President, Fr. Joseph McShane, S.J. arrived on the University of Scranton campus some five years ago, construction of the new Brennan Hall, housing the Kania School of Management, was nearing completion. He hit on the idea of filling the new Hall's many empty corridors with large digital photographs of stained glass windows from northeastern Pennsylvania churches. The purpose was to build a collection that would both create an artistic/religious milieu for the building and reflect the region's important historical heritage.

One element of that heritage was the high quality of the windows, which included several Tiffanys. This reflected the coal-mining boom times of the late nineteenth and early twentieth centuries. Dr. Virginia Raguin, of Holy Cross College, a nationally known specialist in stained glass, explains this background both in the book's general introduction and the separate introductions to each of the eight churches. Maureen Brennan assisted her and was successful in assembling the attached historical data, no easy task given its fragmented nature and the frailty of institutional memory.

This book, of course, stands as a beautiful artistic record in its own right. Please find out for yourself by turning its pages.

Introduction

Part 1

Stained Glass

From Idea to Window

VIRGINIA CHIEFFO RAGUIN

Stained glass, more aptly translated from the German *Glasmalerei* as **glass painting**, is actually large-scale construction of imagery using the medium of glass and vitreous paint. The artist makes a preliminary color sketch. This is then enlarged into a full-scale pattern called a **cartoon**. From this stage the patterns are given to the glazier, who cuts the required colors from the selected sheets of glass whose color has been produced during the molten process of the formation of the glass (**pot-metal glass**). The selection of harmonious colored segments of glass from the thousands of colored sheets available may be one of the most important aspects of making a window. A glass painter then intervenes to paint the elements that must carry the image, such as faces, drapery, or decorative designs. The sections of glass are fired in a kiln to fuse the painted details with the surface of the colored glass. Thus, the image becomes durable over centuries. The fired sections are then joined by malleable lead elements called **cames**. The cames are soldered at their joints and caulked to make them watertight. These leaded sections are set into a larger iron framework and fitted into the stone or wood of the window opening.

In the history of the West, there is no other visual element as closely associated with religious architecture as stained glass. Stained glass has a history almost as long as the medieval monument. The first windows of colored and leaded glass are found in 7th century buildings. The basic composition remains the same, a pattern of colored segments of glass painted with designs in a neutral color and held together by a metal or wood matrix. The traditional stained glass windows of today are very similar to the kind described in a 12th century text *On Divers Arts* by a writer who called himself Theophilus. Theophilus outlined the familiar steps in constructing a window. He paid particular attention to techniques of applying paint, telling the glass painter to take the pigment and "smear it around in such a way that the glass is made transparent in the part where you normally make highlights in a painting," such as for faces, around the eyes, nostrils, chin, and on barefeet and hands. This kind of painted shading has been a part of glass painting throughout time. Theophilus also wrote of removing the paint (done easily before firing) with the pointed handle of a brush to make "circles and branches with flowers and leaves . . . as is done in the case of painted letters (in manuscripts)." Thus, it is clear that in the golden age of stained glass, the art was seen as true painting, indeed, it is one of the most important forms of monumental painting of all time. When stained glass was revived in the 19th century it was also seen as painting. The early pioneers endeavored to make windows look like transparent paintings and linked to the then dominant art of oil painting.

AN ARCHITECTURAL AND PICTORIAL ART IN THE 19TH CENTURY

Stained glass is an art that combines elements of both painting and architecture; the image and color traditional to painting are linked to the function of a building. As the 19th century progressed, patrons encouraged experimentation in many styles of architecture and styles in stained glass followed suit. These styles, such as the English Perpendicular Gothic, were imported to the United States and are exemplified by Covenant Presbyterian Church, built in 1904. The First Presbyterian Church of Wilkes-Barre was built in 1887 in the Romanesque Revival style of red sandstone, inspired by 12th century buildings in the Lombard region of Northern Italy and the Rhineland in Germany. Trinity Church, Carbondale, was begun 1899 in a rural Gothic style, with distinct nave, transept, and chancel, all with high-pitched roofs that evoke English country churches of the 13th century.

Stained glass styles developed in Europe also resonate in American buildings. The style of the *Guardian Angels* windows in Memorial Church is a brilliant example of English Victorian painting. The scenes are painted with enamel, linking them to images on porcelain. The decorative surrounds are in traditional pot-metal glass. In the 1880s American artists, such as Louis Comfort Tiffany and John La Farge, pioneered a style of windows using an opalescent glass. Imported windows from Austria, Germany, France, Spain, Belgium, and England, to name the most popular sources, continued to flow into the country. The windows in St.

Peter's Cathedral by the Franz Mayer Studio, and the windows of Nativity Church by the Zettler Studio, were imported from Munich, Germany, and exemplify inspiration drawn from Renaissance and 17th century Baroque painting. Therefore, there is no one style of window that can be termed American, 19th century, or even correct. What is clear, however, is that all the windows were commissioned for their spaces. Whether for courthouse, cathedral, chapel, synagogue, or private home, individuals saw the glass as illuminating and transforming interior space. These windows need to be preserved or the space they now transform will be irrevocably altered.

AMERICAN INNOVATIONS IN THE 19TH AND 20TH CENTURIES

Beginning with the development of **opalescent** glass in the 1880s, many new processes and techniques were introduced in the art of stained glass. The churches in this book show unusually impressive examples of this type of window. Although traditional techniques were still used by artists and craftspeople, there were more choices. Opalescent glass has variegated colors produced by mixing the still molten glass from different pots. An iridescent sheen was often added by exposing the hot opalescent glass to metallic fumes while in its cooling stages. Additional treatments to opalescent glass can change its appearance. **Confetti glass** receives multicolored chips; other manipulations produced the **mottled color** sea in the trees of *Jesus and Disciples* (p. 46) from Grace Church, Honesdale. **Drapery glass** is manipulated during the cooling process into ridges and furrows, as in the robes of the Christ of the *Ascension* (p. 90) in St. Luke's

Episcopal Church, Scranton. Often textures, such as those of **ripple glass,** can be added by variations in the rollers or the surface of the bed on which the glass rests while cooling.

New structural possibilities for windows were also developed. Instead of a single pane of glass held by the came, artists began to use a technique called **plating**. Two or more (sometimes as many as seven) sheets of glass can be layered with one set behind the other. This permits considerable variations of color and design but it also results in a heavier and more complex window. A visible example of plating appears in the *Angel of the Resurrection* (p. 54) from Memorial Presbyterian Church, Wilkes-Barre. The robes of the angel are given an illusion of three dimensionality by surface layers of translucent glass set strategically over a base layer that groups many different segments. Windows also may contain **beveled glass,** whose edges have been ground at an angle, or **jewels**, sometimes chipped and sometimes cast nuggets that refract light. Jewels appear around the panel containing three crosses in the windows of the *Grapevines and Symbols* (p. 34) in First Presbyterian Church, Wilkes-Barre.

In 1898, a popular writer on the arts of the period, Cecilia Waern, wrote about Tiffany's glass for *The International Studio*. She described the glassworks at Corona, New York, with its stock of 200 to 300 tons of glass on hand partly in cases and partly in numbered racks. The racks displayed close to 5,000 colors and varieties. The machine-rolled varieties were remarkable for their varieties of color. "A pane of dark blue and white, harsh and crude in reflected light, becomes suddenly glorious when seen

in transmitted light, like a sunset all at once illuminating the sky in this land of rich effects. . . . Other pieces suggest priceless onyx or lovely marbles, when seen in reflected light, shot through with throbbing color when held up to the window." Waern also described the handmade glass that retains varying degrees of thickness along with bubbles, and other imperfections that form the accidents of the throwing: "As many as seven different colours out of different ladles or spoons have been thrown together in this way. . . . The throwing of certain masses and colour can be regulated, of course, and a definite design is often employed with a view to providing the glazier with 'useful' glass for obtaining certain effects of drapery, modeling or backgrounds. . . . The famous Tiffany glass [**drapery glass**] is made by manipulating the sheet while still hot as one would do with pastry (with iron hooks, the hands cased in asbestos gloves) and pushing it together until it falls into folds."

The taste for opalescent stained glass that began in the 1880s and 1890s corresponded to a taste for greater opulence in both domestic and public spaces. Luxuriant colors and textures, achieved by the use of inlays and veneers of marble and wood, wallpaper, stenciled painting, and leaded windows, combined for an unusually rich effect often described under the rubric of the American Renaissance. Indeed, the compositions in the Tiffany windows profiled in this book hearken back to Renaissance paintings of the 15th and 16th centuries from artists such as Botticelli and Raphael.

PART 2

LOUIS COMFORT TIFFANY AND TIFFANY STUDIOS

Louis Comfort Tiffany (1848-1933) was the son of Charles Louis Tiffany, founder of the jewelry company, Tiffany & Company of New York. L. C. Tiffany's first company was with three other designers in 1879, Samuel Coleman, Lockwood de Forest, and Candace Wheeler in the firm of L.C. Tiffany & Associated Artists. In 1881 the firm designed the interior of Mark Twain's sumptuous residence in Hartford, Connecticut, and the Fifth Avenue mansions of Ogden Goelet and Cornelius Vanderbuilt II in New York. Tiffany's lifelong production of an astonishing assortment of vases, leaded lamps, jewelry, tableware, mosaics, rugs, chandeliers, wall coverings, and architectural elements may be traced back to his initial move into artistic production as a decorator.

In 1885 Tiffany's work in stained glass had progressed, so that he formed a new company, the Tiffany Glass Company, Inc., which merged five years later with L. C. Tiffany and Associated Artists to become Tiffany Glass and Decorating Company. In 1900 the firm became the Tiffany Studios. The taste for opalescent glass, however, had begun to wane, as taste for the simpler forms of Moderne and Art Deco began their ascendancy. The Second Gothic revival challenged the appropriateness of the "picture window" for a religious edifice, and Tiffany Studios began a gradual decline. In 1932 Tiffany Studios filed for bankruptcy and the following year Tiffany died at the age of eighty-four.

Tiffany's designers, for most windows were not designed by him, were of high calibre and many later founded their own studios. Maitland Armstrong, who would later produce a considerable number of windows with his daughter, designed many of the works emanating from the Tiffany Studios during the 1880s. Edward Peck Sperry, J. A. Holzer, and Agnes Northrop were also prominent designers in the studio. The studio's most characteristic figural work, however, is indebted to the influence of Tiffany's chief designer Frederick Wilson, an Englishman who came in the 1890s and worked for the studio for over 30 years. Wilson's work is characterized by elegant pre-Raphaelite body and facial types with long slender noses, broad foreheads, high cheekbones, and, invariably reddish tonality of hair and beard. The profiles of the Apostles in the mosaic of *The Sermon on the Mount*, now at the Smurfit Arts Center, display his designs. Wilson's draftsmanship is instantly recognizable in the characteristic Tiffany angel, as seen at the First Presbyterian Church of Wilkes-Barre, Trinity Church, Carbondale, or Covenant Presbyterian Church, Scranton.

MAYER AND ZETTLER STUDIOS, MUNICH, GERMANY

The extant list of commissions kept by Franz Mayer & Company, Munich, Germany, notes windows made for St. Peter's Cathedral in Scranton, PA. Mayer was a longlived studio that exported large numbers of windows to the United States. Founded in 1848 by Joseph Gabriel Mayer (1808-1883), and continued by his sons Joseph Gabriel Mayer (+1898) and Franz Borgais Mayer (1848-1926), the complete name of the firm is

the Franz Mayer'sche Hofkunstanstalt und Glasmalerei. Mayer's earliest work in the United States may be a 1874 signed window for the Episcopal Church of St. James the Less, Philadelphia, PA. The studio chronicles 25 cathedrals in the United States with at least some stained glass by Mayer and Company.

The Franz Zettler Studio was a rival of Mayer. Franz Xavier Zettler (1841-1916) founded the enterprise in 1870, which was later managed by his two sons, Franz (1865-?) and Oskar (1875-?). The Zettler Studio furnished American churches with glass; a division of the firm was managed from New York by Oskar Zettler. In 1873 the ruler of Bavaria, King Ludwig II, bestowed the title "Royal Bavarian Art Institute for Pictorial Paintings on Glass" on the Zettler studio. The studio advertised that it studied the technique of old masters, acquired through the restoration of medieval windows in Bavaria and Alsace. A grandson, Oskar Zettler (born 1902) later managed the firm until 1939, when it merged with Franz Mayer & Company. In reality, both the Mayer and the Zettler firms were extremely close in style and concept. The members of the firms intermarried and invariably craftspersons would move from one to the other enterprise. The Zettler list of commissions notes not only Scranton, but specific clergyman, Dr. J. J. Loughran, who ordered the windows of Nativity Church.

The Munich stained glass studios boasted large workshops, sophisticated ovens, and well-trained craftpersons. Enamel colors or traditional neutral paint were fired under ideal conditions. The structural integrity of the window was insured by the employment of standard sizes and types of glass

segments, lead came, and the support structure of iron frame and saddle bars. The studios were often favored by Catholic patrons, who could rely on the window designers' complete familiarity with Roman Catholic pictorial traditions, such as the *Mysteries of the Rosary*, depicted in the Church of the Nativity, or favorite saints of ethic popularity, as shown by St. Patrick in Scranton's Cathedral. The *Coronation of the Virgin* at the Nativity church shows the Trinity in clear terms. Christ is a young man with a cruciform halo, God the Father has a long gray beard and a halo with a triangle symbolizing the triune nature of the Divinity, and the Holy Spirit is a dove radiant with light, hovering over the scene.

The development of the Munich style of glass painting, perhaps more than that of any other European country, was a part of contemporaneous trends in painting, specifically the Nazarene movement of Romantic landscape and figural painting. Both the northern medieval traditions and the Italian Renaissance were inspirations. The style emphasized solid modeling and bold graphic systems. Such windows employ a considerable amount of white glass, designated areas of strong color, and three-dimensional modeling of forms.

REFERENCES

* Brown, Sarah. *Stained Glass: An Illustrated History*. New York: Crescent Books, 1992.

* Duncan, Alastair. *Tiffany Windows*. New York: Simon & Schuster, 1980.

* Fischer, Josef Ludwig. *Vierzig Jahre Glasmalkunst*. Kommissions Verlag Georg Muller, Munich, 1910 (History of the first 40 years of the F. X. Zettler firm)

* *The Catholic Encyclopedia* and *The New Catholic Encyclopedia*

* Ogren, Robert E. *The First Presbyterian Church of Wilkes-Barre, Pennsylvania: History of the Sanctuary, Stained Glass Windows and Pipe Organs 1886-1998*. Wilkes-Barre: First Presbyterian Church, 1998.

* Ferguson, George. *Signs and Symbols in Christian Art*. New York: Oxford University Press, 1961.

* Frelinghuysen, Alice Cooney. "Louis Comfort Tiffany at the Metropolitan Museum," *The Metropolitan Museum of Art Bulletin* 56/1 (Summer 1998).

* Hall, James. *Dictionary of Subjects & Symbols in Art*. Icon Editions, New York: Harper & Row, 1979.

* Harrison, Martin. *Victorian Stained Glass*. London: Barrie and Jenkins, 1980.

* *Masterworks of Louis Comfort Tiffany*. National Museum of American Art, Washington D.C., New York, 1989. Essays by Alastair Duncan, Martin Eidelberg, Neil Harris.

* McKean, Hugh. *The "Lost Treasures" of Louis Comfort Tiffany*. New York: Doubleday and Company, 1980.

* Raguin, Virginia. *Glory in Glass: Stained Glass in the United States: Origin, Variety an Preservation*, The Gallery at the American Bible Society, New York, November 12, 1998-February 16, 1999.

* Raguin, Virginia. *Testimony of the Light: American Stained Glass and Architecture in the 20th Century*, The Gallery at the American Bible Society, December 13, 2002-March 16, 2003.

* Taves, Ann. *The Household of Faith*. University of Notre Dame Press, 1990.

Covenant Presbyterian Church

Covenant Presbyterian Church stands on the corner of Madison Avenue and Olive Street in central Scranton, Pennsylvania. It was originally called the First Presbyterian Church of Scranton and later the Westminster Presbyterian Church. The congregation was established in 1848 and consisted of many of Scranton's founding families. Dedicated on October 24, 1904, the present church building shows the English perpendicular Gothic (15th century) with some Tudor (16th century) touches on the interior. Built of brick and dressed limestone, it was designed by the architect Lansing C. Holden and built by Peter Stripp. The church is a very large and impressive structure. Even in its current urban setting, the church, originally built when the area was rural, evokes the feeling of an English cathedral.

The complex window openings are clearly designed for stained glass. However, its windows were donated one by one over time, typical of American churches of the day. The earliest windows were created by Tiffany Studios. In the upper windows of the sanctuary, in the center, is the *Ascension*, probably installed shortly after 1905. To the right is the *Resurrection*, dated 1911, and then on the left, the *Last Supper* and *Christ's Entry into Jerusalem*, both installed after 1923. In the nave on the first floor are five windows from Tiffany Studios; *Christ and Disciples*, *Good Samaritan*, and *Jesus Blessing the Children*. These windows are signed and dated "Tiffany Studios, New York, 1915." Two others, the *Supper at Emmaus*, and the *Good Shepherd*, though not signed, are similar in style and appear to be from the same era. *Christ Knocking at the Door*, however, installed after 1923, was signed by Louis C. Tiffany Studios, NY. The windows show the hallmarks of Tiffany Studio, especially the work and designs of Frederick Wilson. The *Ascension*, for example, is almost exactly like a Tiffany *Ascension* installed in St. Matthew's Episcopal Church in Worcester, Massachusetts in 1896. The *Good Shepherd* is similar in theme and composition to a window in Arlington Street Church, Boston, MA. In addition to the Tiffany work, a large window of *Jesus and the Samaritan Woman at the Well*, in opalescent glass, was designed by La Farge of New York City. Set in the nave balcony, the window must have been installed before 1911, the year of La Farge's death. Later stained glass windows were made by such prestigious studios as the D'Ascenzo Studio of Philadelphia (1929), the Willet Studios of Philadelphia (1938), and by the Baut Studios of Swoyersville, PA (1969). The nine windows depicted in this book, however, are all attributed to Tiffany Studios, NY.

1

Very truly, I tell you, anyone who does not enter the sheepfold by the gate but climbs in by another way is a thief and a bandit. The one who enters by the gate is the shepherd of the sheep. The gatekeeper opens the gate for him, and the sheep hear his voice. He calls his own sheep by name and leads them out. When he has brought out all his own, he goes ahead of them, and the sheep follow him because they know his voice. They will not follow a stranger, but they will run from him because they do not know the voice of strangers.' Jesus used this figure of speech with them, but they did not understand what he was saying to them."

"So again Jesus said to them, 'Very truly, I tell you, I am the gate for the sheep. All who came before me are thieves and bandits; but the sheep did not listen to them. I am the gate. Whoever enters by me will be saved, and will come in and go out and find pasture. The thief comes only to steal and kill and destroy. I came that they may have life, and have it abundantly.' "

" 'I am the good shepherd. The good shepherd lays down his life for the sheep. The hired hand, who is not the shepherd and does not own the sheep, sees the wolf coming and leaves the sheep and runs away – and the wolf snatches them and scatters them. The hired hand runs away because a hired hand does not care for the sheep. I am the good shepherd. I know my own and my own know me, just as the Father knows me and I know the Father. And I lay down my life for the sheep. I have other sheep that do not belong to this fold. I must bring them also, and they will listen to my voice. So there will be one flock, one shepherd. For this reason the Father loves me, because I lay down my life in order to take it up again. No one takes it from me, but I lay it down of my own accord. I have power to lay it down, and I have power to take it up again. I have received this command from my Father.' "

Though not signed, it is similar to other signed Tiffany windows in the church and reflects the work of the designer Frederick Wilson. Probably installed sometime between 1904-1915, it is a memorial to William W. Manness (1816-1893) and Elvira C. Manness (1826-1893). Notice the similarity of this window to the Good Shepherd window in the First Presbyterian Church, Wilkes-Barre, PA.

Covenant Presbyterian Church, Scranton ❖ *John 10:1-18* ❖ *The Good Shepherd*

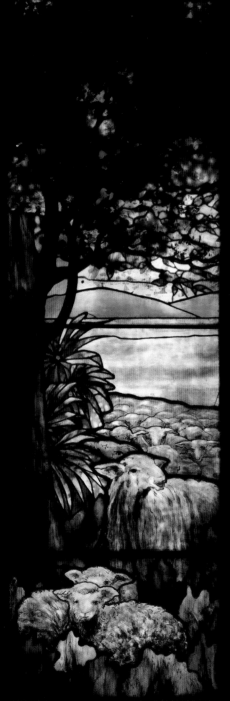

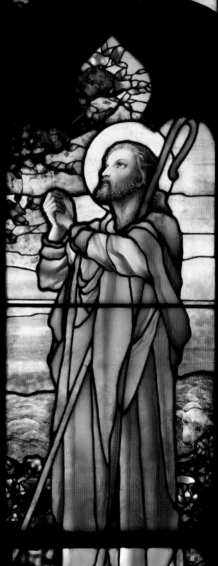

2

Though this window portraying Jesus standing at the door and knocking is, strictly speaking, not a New Testament image, it does call to mind the image of the Good Shepherd. Jesus sees and describes himself as the shepherd who helps the sheep, especially those who have no shepherd. His disciples are seen as a little flock that he has gathered in representation of the eschatological community of the Kingdom. Though the flock will be endangered by wolves roaming outside the paddock and by those disguised as sheep within it, they shall nevertheless be protected and gathered together, in the long run, into a family. The modern symbol of knocking on the door reflects the shepherd opening the gate to go into the sheepfold to feed, support, and protect the sheep. In some ways, Jesus himself is the doorway through which the sheep pass. Good sheep recognize the shepherd and welcome him. Sinners refuse to hear his call and, at the end of time, the good and the wicked sheep will be separated. This mission of attending the sheep of faith is handed down by Jesus to his disciples who are charged "feed my sheep." In brief, God knocks at the human heart, and our responsibility is to open the door and recognize the Good Shepherd who brings us a new life and a new love.

Signed Louis C. Tiffany. A memorial to Sarah Griffin (1834-1910). When this window was installed is not certain, but it was probably after 1923.

Covenant Presbyterian Church, Scranton ❖ *Behold, I Stand at the Door and Knock*

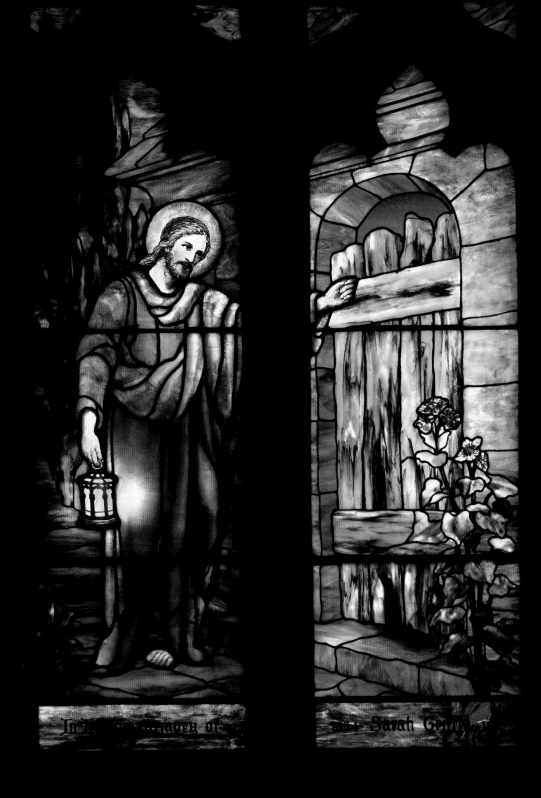

In ... memory of ... Sarah Griffith ...

3

People were bringing little children to him in order that he might touch them; and the disciples spoke sternly to them. But when Jesus saw this, he was indignant and said to them, 'Let the little children come to me; do not stop them; for it is to such as these that the kingdom of God belongs. Truly I tell you, whoever does not receive the kingdom of God as a little child will never enter it.' And he took them up in his arms, laid his hands on them, and blessed them. . . ."

Signed Tiffany Studios, NY, 1915. A memorial to Charles Fuller (1797-1881) and Maria S. Fuller (1799-1874).

Covenant Presbyterian Church, Scranton ❖ *Mark 10:13-16 & Luke 18:15-17*
Jesus Blessing the Children

9

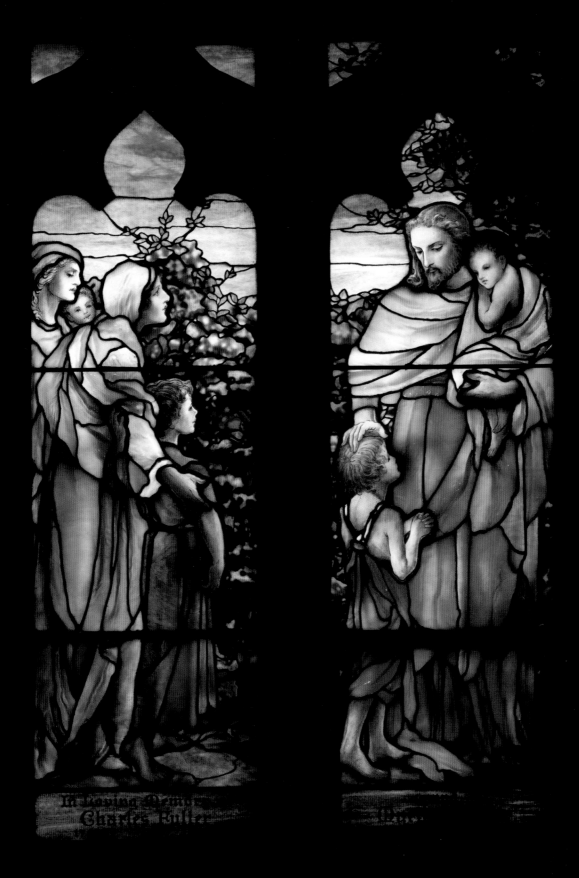

In Loving Memory
Charles Ryle

4

just then a lawyer stood up to test Jesus. 'Teacher,' he said, 'what must I do to inherit eternal life?' He said to him, 'What is written in the law? What do you read there?' He answered, 'You shall love the Lord your God with all your heart, and with all your soul, and with all your strength, and with all your mind; and your neighbor as yourself.' And he said to him, 'You have given the right answer; do this, and you will live!' "

"But wanting to justify himself, he asked Jesus, 'And who is my neighbor?' Jesus replied, 'A man was going down from Jerusalem to Jericho, and fell into the hands of robbers, who stripped him, beat him, and went away, leaving him half dead. Now by chance a priest was going down that road; and when he saw him, he passed by on the other side. So likewise a Levite, when he came to the place and saw him, passed by on the other side. But a Samaritan while traveling came near him; and when he saw him, he was moved with pity. He went to him and bandaged his wounds, having poured oil and wine on them. Then he put him on his own animal, brought him to an inn, and took care of him. The next day he took out two denarii, gave them to the innkeeper, and said, 'Take care him; and when I come back, I will repay you whatever more you spend.' Which of these three, do you think, was a neighbor to the man who fell into the hands of the robbers?' He said, 'The one who showed him mercy.' Jesus said to him, 'Go and do likewise.' "

Signed Tiffany Studios, New York. A memorial to Alexander W. Dickson (1840-1912). The town in the background is similar to the "Nativity" window in Nativity Church, Scranton, Pennsylvania.

Covenant Presbyterian Church, Scranton ❖ *Luke: 10:25-37* ❖ *The Good Samaritan*

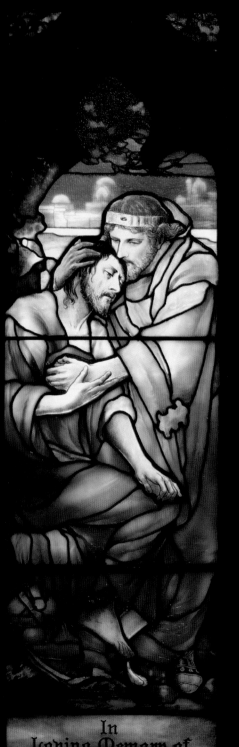

In
Loving Memory of

Alexander W. Dickson
1843 —— 1912

5

After he had said this, he went on ahead, going up to Jerusalem. When he had come near Bethphage and Bethany, at the place called the Mount of Olives, he sent two of the disciples, saying, 'Go into the village ahead of you, and as you enter it you will find tied there a colt that has never been ridden. Untie it and bring it here. If anyone asks you, "Why are you untying it?" just say this, "The Lord needs it." ' So those who were sent departed and found it as he had told them. As they were untying the colt, its owners asked them, 'Why are you untying the colt?' They said, 'The Lord needs it.' Then they brought it to Jesus; and after throwing their cloaks on the colt, they set Jesus on it. As he rode along, people kept spreading their cloaks on the road. As he was now approaching the path down from the Mount of Olives, the whole multitude of the disciples began to praise God joyfully with a loud voice for all the deeds of power that they had seen, saying,

'Blessed is the king
who comes in the name of the Lord!
Peace in heaven, and glory in the highest heaven!"

"Some of the Pharisees in the crowd said to him, 'Teacher, order your disciples to stop.' He answered, 'I tell you, if these were silent, the stones would shout out.' As he came near and saw the city, he wept over it. . . ."

Installed after 1915. A memorial to James W. Fowler (1838-1903) and Achsah D. Fowler (1837-1925).

Covenant Presbyterian Church, Scranton ❖ Luke 19:28-41 ❖ Triumphal Entry into Jerusalem

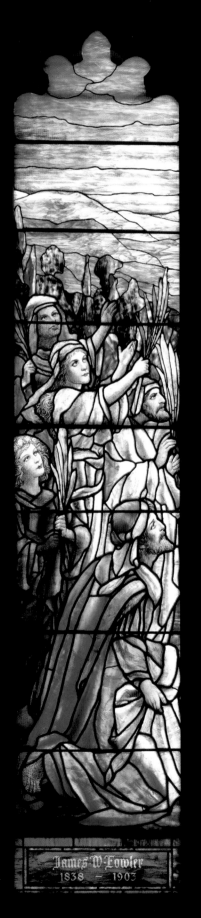

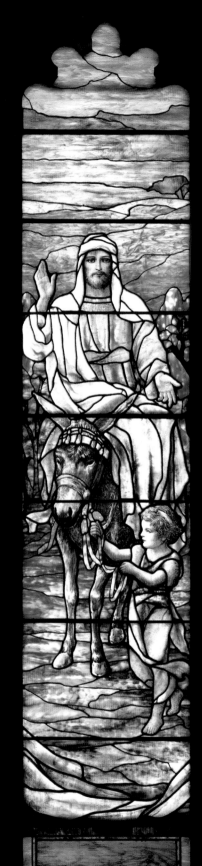

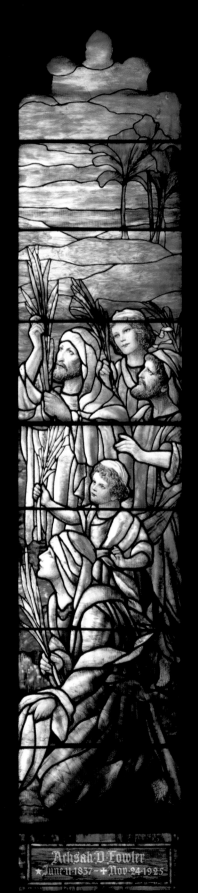

James W. Fowler
1838 — 1903

Achsah D. Fowler
★ June 11 1837 ✝ Nov 24 1925

Then came the day of Unleavened Bread, on which the Passover lamb had to be sacrificed. So Jesus sent Peter and John, saying, 'Go and prepare the Passover meal for us that we may eat it.' They asked him, 'Where do you want us to make preparations for it?' 'Listen,' he said to them, 'when you have entered the city, a man carrying a jar of water will meet you; follow him into the house he enters and say to the owner of the house, "The teacher asks you 'Where is the guest room, where I may eat the Passover with my disciples?' 'He will show you a large room upstairs, already furnished. Make preparations for us there.' So they went and found everything as he had told them; and they prepared the Passover meal."

"When the hour came, he took his place at the table, and the apostles with him. He said to them, 'I have eagerly desired to eat this Passover with you before I suffer; for I tell you, I will not eat it until it is fulfilled in the kingdom of God.' Then he took a cup, and after giving thanks he said, 'Take this and divide it among yourselves; for I tell you that from now on I will not drink of the fruit of the vine until the kingdom of God comes.' Then he took a loaf of bread, and when he had given thanks, he broke it and gave it to them, saying, 'This is my body, which is given for you. Do this in remembrance of me.' And he did the same thing with the cup after supper, saying, 'This cup that is poured out for you is the new covenant in my blood. But see, the one who betrays me is with me, and his hand is on the table. For the Son of Man is going as it has been determined, but woe to that one by whom he is betrayed!' Then they began to ask one another, which one of them it could be who would do this."

"A dispute also arose among them as to which one of them was to be regarded as the greatest. But he said to them, 'The kings of the Gentiles lord it over them; and those in authority over them are called benefactors. But not so with you; rather the greatest among you must become like the youngest, and the leader like one who serves. For who was greater, the one who is at the table or the one who serves? Is it not the one at the table? But I am among you as one who serves.' "

Created and installed sometime after 1923. A memorial to Simon Jones (1821-1875) and Ellen Lazarus Jones (1818-1904). Attributed to Tiffany Studios, New York.

Covenant Presbyterian Church, Scranton ❖ *Luke 22:7-27* ❖ *The Last Supper*

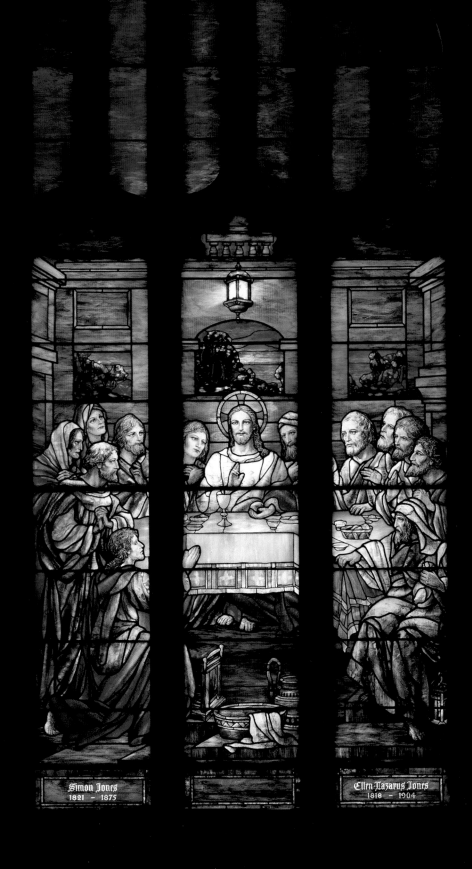

Simon Jones
1821 – 1875

Ellen Lazarus Jones
1818 – 1904

7

Early on the first day of the week, while it was still dark, Mary Magdalene came to the tomb and saw that the stone had been removed from the tomb. So she ran and went to Simon Peter and the other disciple, the one whom Jesus loved, and said to them, 'They have taken the Lord out of the tomb, and we do not know where they have laid him.' Then Peter and the other disciple set out and went to the tomb. The two were running together, but the other disciple outran Peter and reached the tomb first. He bent down to look in and saw the linen wrappings lying there, but he did not to go in. Then Simon Peter came, following him, and went into the tomb. He saw the linen wrappings lying there, and the cloth that had been on Jesus' head, not lying with the linen wrappings but rolled up in a place by itself. Then the other disciple, who reached the tomb first, also went in, and he saw and believed; for as yet they did not understand the scripture, that he must rise from the dead. Then the disciples returned to their homes."

"But Mary stood weeping outside the tomb. As she wept, she bent over to look into the tomb, and she saw two angels in white, sitting where the body of Jesus had been lying, one at the head and the other at the feet. They said to her, 'Woman, why are you weeping?' She said to them! 'They have taken away my Lord, and I do not know where they have laid him.' When she had said this, she turned around and saw Jesus standing there, but she did not know that it was Jesus. Jesus said to her, 'Woman, why are you weeping? Whom are you looking for?' Supposing him to be the gardener, she said to him, 'Sir, if you have carried him away, tell me where you have laid him, and I will take him away.' Jesus said to her, 'Mary!' She turned and said to him in Hebrew, 'Rabbouni!' (which means Teacher). Jesus said to her, 'Do not hold on to me, because I have not yet ascended to the Father. But go to my brothers and say to them, "I am ascending to my Father and your Father, to my God and your God." ' Mary Magdalene went and announced to the disciples, 'I have seen the Lord'; and she told them that he had said these things to her."

Installed around Easter time in 1911. Dedicated as a memorial to the Hallstead family. Attributed to Tiffany Studios.

Covenant Presbyterian Church, Scranton ❖ *John 20:1-18* ❖ *The Resurrection Angel*

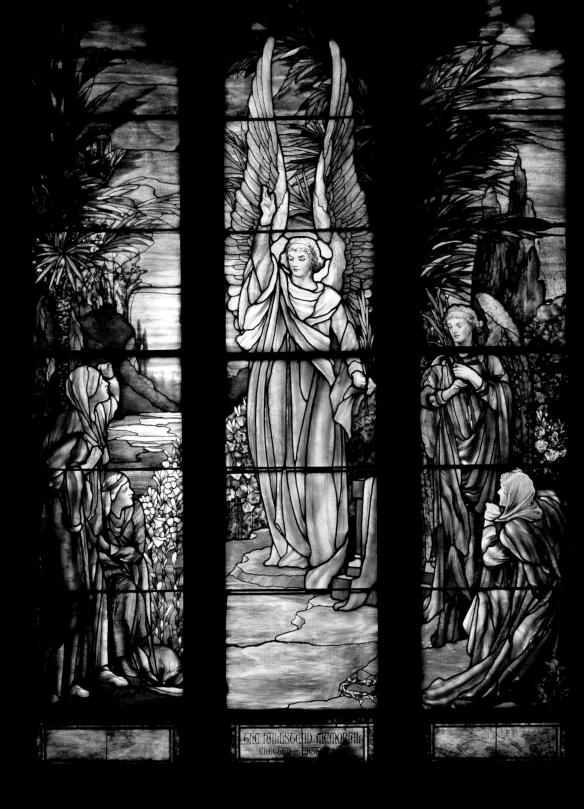

THE HALLSTEAD MEMORIAL
ERECTED — [illegible]

8

Now on that same day two of them were going to a village called Emmaus, about seven miles from Jerusalem, and talking with each other about all these things that had happened. While they were talking and discussing, Jesus himself came near and went with them, but their eyes were kept from recognizing him. And he said to them, 'What are you discussing with each other while you walk along?' They stood still, looking sad. Then one of them, whose name was Cleopas, answered him, 'Are you the only stranger in Jerusalem who does not know the things that have taken place there in these days?' He asked them, 'What things?' They replied, 'The things about Jesus of Nazareth, who was a prophet mighty in deed and word before God and all the people, and how our chief priests and leaders handed him over to be condemned to death and crucified him. But we had hoped that he was the one to redeem Israel. Yes, and besides all this, it is now the third day since these things took place. Moreover, some women of our group astounded us. They were at the tomb early this morning, and when they did not find his body there, they came back and told us that they had indeed seen a vision of angels who said that he was alive. Some of those who were with us went to the tomb and found it just as the women had said; but they did not see him.' Then he said to them, 'Oh, how foolish you are, and how slow of heart to believe all that the prophets have declared! Was it not necessary that the Messiah should suffer these things and then enter into his glory?' Then beginning with Moses and all the prophets, he interpreted to them the things about himself in all the scriptures."

"As they came near the village to which they were going, he walked ahead as if he were going on. But they urged him strongly, saying, 'Stay with us, because it is almost evening and the day is now nearly over.' So he went in to stay with them. When he was at the table with them, he took bread, blessed and broke it, and gave it to them. Then their eyes were opened, and they recognized him; and he vanished from their sight. They said to each other, 'Were not our hearts burning within us while he was talking to us on the road, while he was opening the scriptures to us?' That same hour they got up and returned to Jerusalem; and they found the eleven and their companions gathered together. They were saying, 'The Lord has risen indeed, and he has appeared to Simon!' Then they told what had happened on the road, and how he had been made known to them in the breaking of the bread."

Signed Tiffany Studios, New York. Installed sometime between 1914 and 1923. A memorial to Alexander E. Hunt (1835-1914) and to Frances E. Hunt (1837-1911).

Covenant Presbyterian Church, Scranton ❖ *Luke 24:13-3*
Christ and the Disciples at Emmaus

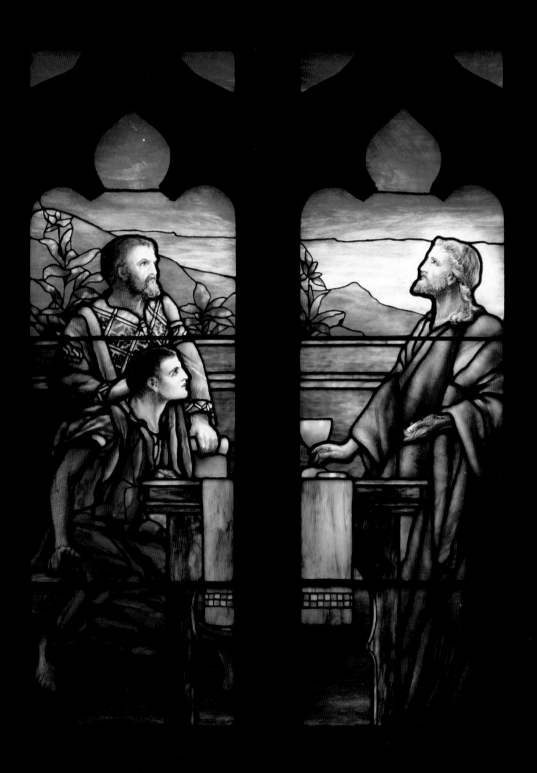

9

After the Sabbath, as the first day of the week was dawning, Mary Magdalene and the other Mary went to see the tomb. And suddenly there was a great earthquake; for an angel of Lord, descending from heaven, came and rolled back the stone and sat on it. His appearance was like lightning, and his clothing white as snow. For fear of him the guards shook and became like dead men. But the angel said to the women, 'Do not be afraid; I know that you are looking for Jesus who was crucified. He is not here; for he has been raised, as he said. Come, see the place where he lay. Then go quickly and tell his disciples, "He has been raised from the dead, and indeed he is going ahead of you to Galilee; there you will see him." This is my message for you.' So they left the tomb quickly with fear and great joy, and ran to tell his disciples. Suddenly Jesus met them and said, 'Greetings!' And they came to him, took hold of his feet, and worshiped him. Then Jesus said to them, 'Do not be afraid; go and tell my brothers to go to Galilee; there they will see me. . . .' "

"Now the eleven disciples went to Galilee, to the mountain to which Jesus had directed them. When they saw him, they worshiped him; but some doubted. And Jesus came and said to them, 'All authority in heaven and on earth has been given to me. Go therefore and make disciples of all nations, baptizing them in the name of the Father and of the Son and of the Holy Spirit, and teaching them to obey everything that I have commanded you. And remember, I am with you always, to the end of the age.' "

Installed shortly after 1904 when the Church was built. Inscribed as a memorial to J. Curtis Platt (1816-1887) and Catherine S. Scranton (1822-1887). Attributed to Tiffany Studios, New York.

Covenant Presbyterian Church, Scranton ❖ *Matthew 28:1-10;16-20* ❖ *The Ascension*

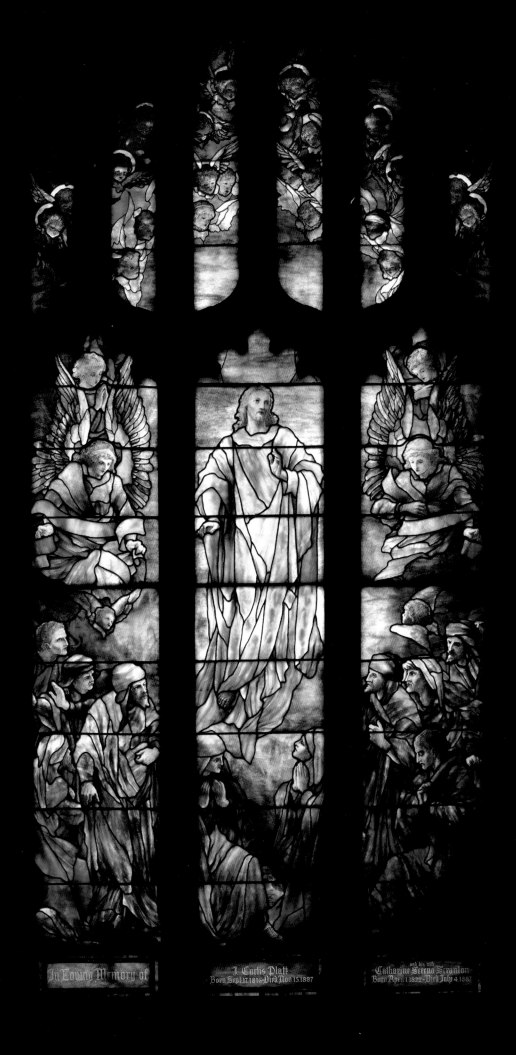

In Loving Memory of

J. Curtis Platt
Born Sept. 17, 1816 – Died Nov. 15, 1887

and his wife
Catharine Serena Scranton
Born April 1, 1822 – Died July 4, 1887

FIRST
PRESBYTERIAN
CHURCH

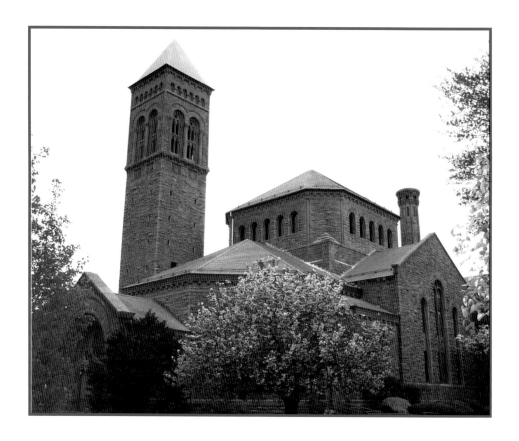

The First Presbyterian Church of Wilkes-Barre was built in 1887 in the Romanesque Revival style. The architects, James Cleveland Cady & Co., of New York City, were also the designers of the National Presbyterian Church of Washington, DC., and the Metropolitan Opera House, New York. Its exterior walls were built of native red sandstone and trimmed with Long Meadows stone. The round-arched style exemplified by the First Presbyterian Church was inspired by 12th century buildings found throughout Europe, but particularly from the Lombard region of northern Italy and the Rhineland in Germany. It is characterized by an emphasis on the flat plane of the wall, rounded arches, and restrained ornamentation,

which includes corbelled friezes. The profile of the building achieves asymmetrical design through the contrast of the low octagonal tower at the crossing and the tall vertical bell tower.

The earliest windows in the church were designed by the Hardman Studios of Birmingham, England (1880)s, Tiffany Studios, NY (1890s-1920s), and Baut Studios, Swoyersville, PA (1998). Of the church's Tiffany windows, six are featured in this book. Two *Herald Angel* windows show angels with trumpets floating in clouds accompanied by birds; the *Truth Figure* window is an eight-lobed window showing a figure carrying a sword and burning lamp. The *Resurrection Angels* window, dedicated in 1924, is a sample of a later Tiffany window; The *Good Shepherd* windows have a characteristic vivid landscape background made famous by the Tiffany Studios. The series was dedicated on Easter Sunday 1906. The *Grapevine and Symbols* window reflects early Christian themes of curving vines within architectural frames familiar from mosaics in Italian churches. To the left is the Chi Rho, an X and P, Greek letters that begin the name Christ. It is embellished with a horizontal line to suggest the cross. On the right the letters IHS appear. These are the first three letters of the name of Jesus in Greek. Above is a window of the *Good Shepherd* with the characteristic vivid landscape background made famous by the Tiffany Studios.

10

In the latter part of the Hebrew Bible, some of the important messengers of God are given special names derived from their special functions: Raphael is seen as the the healer, "And at the same time God sent me to heal you and Sarah, your daughter-in-law. I am Raphael, one of the seven Angels who stand ready and enter before the glory of the Lord." (Tobit 12:14-15); Gabriel is seen as God's hero: "When I Daniel, had seen the vision, I tried to understand it. Then someone appeared before me, having the appearance of a man, and I heard a human voice by the Ulai, calling, 'Gabriel, help this man understand the vision.' So he came near where I stood, and when he came, I became frightened and fell prostrate. But he said to me, 'Understand, O mortal, that the vision is for the time of the end.' " (Daniel 8:15-17) And, in the New Testament, Michael is the defender against evil: "And war broke out in heaven; Michael and his angels fought against the dragon. The dragon and his angels fought back, but they were defeated, and there was no longer any place for them in heaven. The great dragon was thrown down, that ancient serpent, who is called the Devil and Satan, the deceiver of the whole world he was thrown down to the earth, and his angels were thrown down with him." (Revelation: 12:7-9)

Tiffany Studios. Window dedicated on Easter Sunday, 1906. A memorial for George Murray Reynolds, born July 16, 1938, died September 24, 1904. The window was restored in 1998, at which time a second memorial was added for Arthur John Thomas, who died Sept 11, 1950, in an accident on a 109th Field Artillery train. Colonel Reynolds was a former Trustee and past President of the Board of Trustees of the church when he died.

First Presbyterian Church, Wilkes-Barre ❖ *Herald Angels (left)*

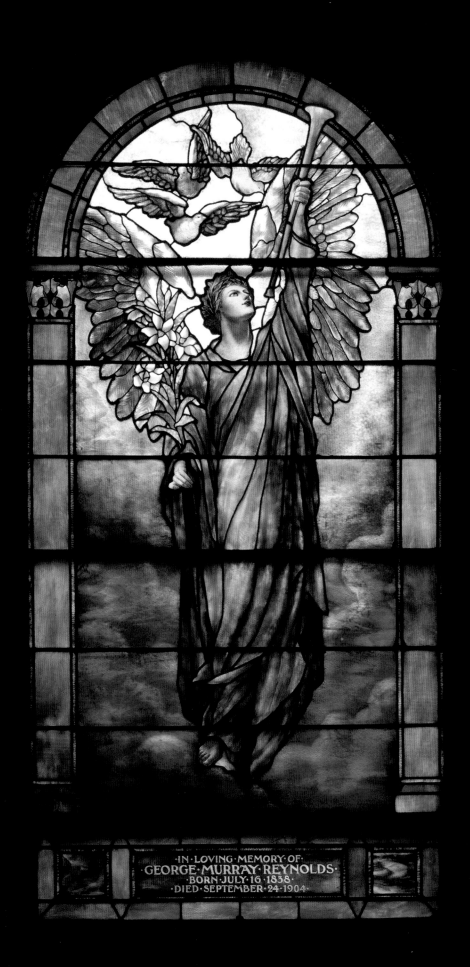

IN·LOVING·MEMORY·OF
GEORGE·MURRAY·REYNOLDS
·BORN·JULY·16·1838·
·DIED·SEPTEMBER·24·1904·

11

I n the New Testament we find the angels closely intertwined with a life of Jesus. This can be seen at the end of the temptation in the desert, "Then the devil left him, and suddenly angels came and waited on him" (Matthew 4:11). Jesus says "Take care that you do not despise one of these little ones; for, I tell you, in heaven their angels continually see the face of my Father in heaven" (Matthew 18:10–11). "But about that day and hour no one knows, neither the angels of heaven, nor the Son, but only the Father." (Matthew 24:36). God will "send out his angels with a loud trumpet call, and they will gather his elect from the four winds, from one end of heaven to the other" (Matthew 24:31). "I tell you, there will be more joy in heaven over one sinner who repents than over ninety-nine righteous persons who need no repentance" (Luke 15:7). The angels contemplate the mystery of the son of God, "He was revealed in flesh, vindicated in spirit, seen by angels, proclaimed among Gentiles, believed in throughout the world, taken up in glory" (I Timothy 3:16) (1 Corinthians 15:51-58).

Tiffany Studios. Installed Easter Sunday, 1906. A memorial to Stella Dorrance (1840-1904), daughter of the Reverend John Dorrance, who was minister when the church was built. In the 1908 restoration, it was also dedicated to the memory of Arthur John Thomas, who died in the 1950, 109th Field Artillery train accident.

First Presbyterian Church, Wilkes-Barre ❖ *Herald Angels (right)*

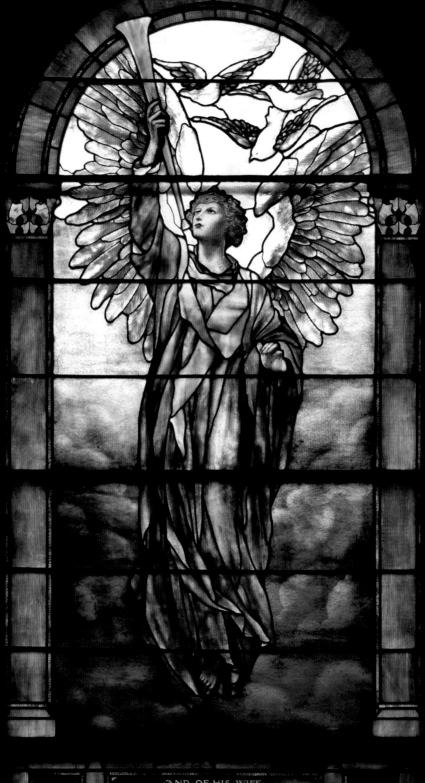

·AND·OF·HIS·WIFE·
·STELLA·DORRANCE·REYNOLDS·
·BORN·DECEMBER·3·1840·
·DIED·NOVEMBER·13·1904·

12

A fter this I looked, and there in heaven a door stood open! And the first voice, which I had heard speaking to me like a trumpet, said, 'Come up here, and I will show you what must take place after this.' At once I was in the spirit, and there in heaven stood a throne, with one seated on the throne! And the one seated there looks like jasper and carnelian, and around the throne is a rainbow that looks like an emerald. Around the throne are twenty-four thrones, and seated on the throne are twenty-four elders, dressed in white robes, with golden crowns on their heads. Coming from the throne are flashes of lightning, and rumblings and peals of thunder, and in front of the throne burn seven flaming torches, which are the seven spirits of God; and in front of the throne there is something like a sea of glass, like crystal."

"Around the throne, and on each side of the throne, are four living creatures, full of eyes in front and behind: the first living creature like a lion, the second living creature like an ox, the third living creature with a face like a human face, and the fourth living creature like a flying eagle. And the four living creatures, each of them with six wings, are full of eyes all around and inside. Day and night without ceasing they sing,

'Holy, Holy, Holy, the Lord God the almighty,
who was and is and is to come.' "

"And whenever the living creatures give glory and honor and thanks to the one who is seated on the throne, who lives forever and ever, the twenty-four elders fall before the one who is seated on the throne and worship the one who lives forever and ever; they cast their crowns before the throne singing,

'You are worthy, our Lord and God,
to receive glory and honor and power,
for you created all things,
and by your will they existed and were created.' "

Signed, Louis C. Tiffany, New York. Dedicated in 1924 in honor of John Welles Hollenbach (1827-1923). It portrays Mary Magdalen and two angels.

First Presbyterian Church, Wilkes-Barre ❖ Revelation 4:1-11 ❖ Resurrection Angels

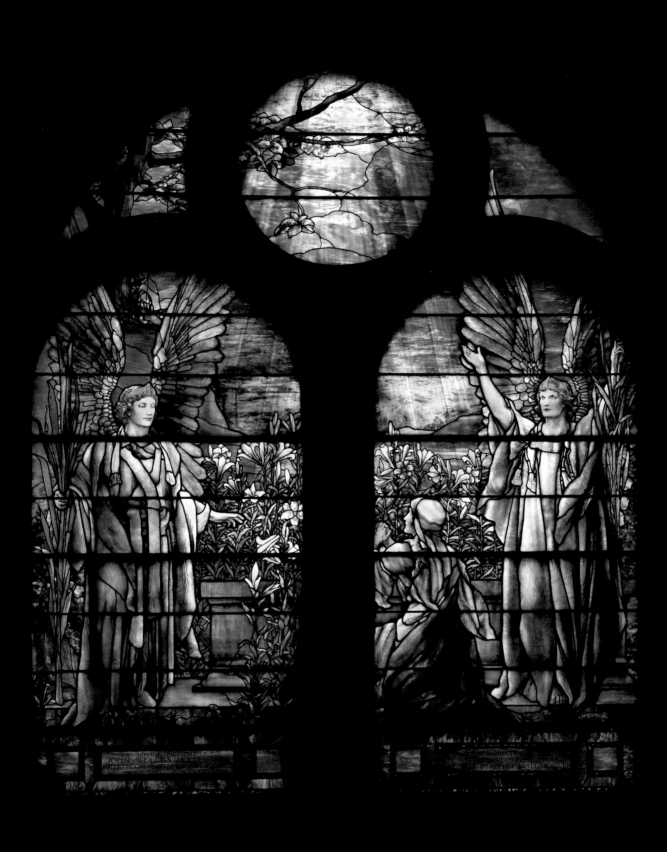

13

The vine has been a biblical symbol from time immemorial. It plays a central role in the imagery of the prophets, especially in Isaiah, chapter 5:1-7, where God, through the prophets, speaks almost plaintively of all that he has done for the vine (his people): "My beloved had a vineyard on a very fertile hill. He dug it and cleared it of stones, and planted it with choice vines; he built a watchtower in the midst of it, and hewed out a wine vat in it; he expected it to yield grapes, but it yielded wild grapes. And now, inhabitants of Jerusalem and people of Judah, judge between me and my vineyard." (Isaiah 5:1-3)

> "What more was there to do for
> my vineyard
> that I have not done in it?
> When I expected it to yield grapes
> why did it yield wild grapes?" (Isaiah 5:4)

"In the New Testament, Jesus is the vine, 'I am the true vine . . . Abide in me as I abide in you . . . I am the vine, you are the branches.' (John 15:1, 4-5). Without this union with Jesus we are cut off from the sap or source of life. He calls all men and women to this connectedness. This life-giving vine brings us the fruit of the Spirit. Since his disciples thus share in his joy, the joy of the son who glorifies the father, it is fitting that this window commemorates joy."

Signed, Tiffany Studios, dedicated on Easter Sunday 1906. A memorial to Reverend Francis Blanchard Hodge, D.D. For 33 years the beloved pastor of this church. This window is below the "Good Shepherd" window and both are in memory of Rev. Hodge, the minister at the time the current church building was erected.

First Presbyterian Church, Wilkes-Barre ❖ *Grapevine and Symbols*

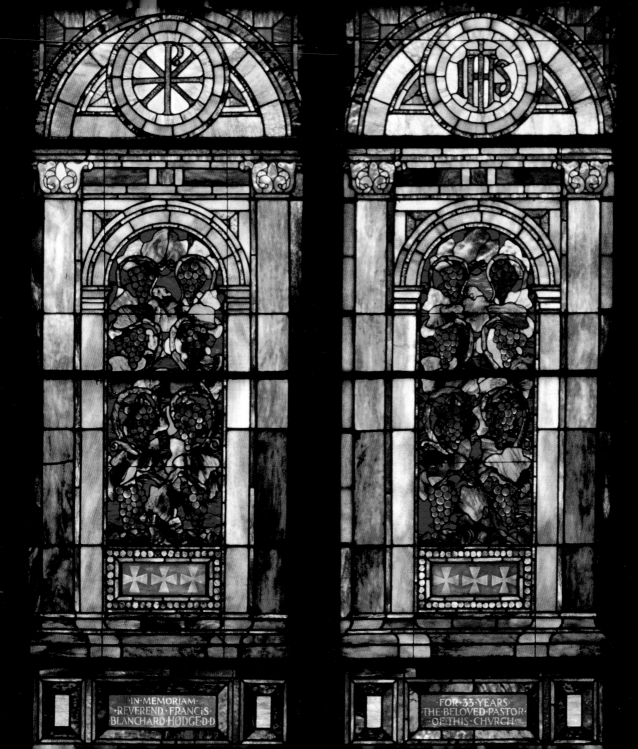

IN MEMORIAM
REVEREND FRANCIS
BLANCHARD HODGE D·D

FOR·33·YEARS·
THE·BELOVED·PASTOR·
OF·THIS·CHVRCH·

14

Very truly, I tell you, anyone who does not enter the sheepfold by the gate but climbs in by another way is a thief and a bandit. The one who enters by the gate is the shepherd of the sheep. The gatekeeper opens the gate for him, and the sheep hear his voice. He calls his own sheep by name and leads them out. When he has brought out all his own, he goes ahead of them, and the sheep follow him because they know his voice. They will not follow a stranger, but they will run from him because they do not know the voice of strangers.' Jesus used this figure of speech with them, but they did not understand what he was saying to them."

"So again Jesus said to them, 'Very truly, I tell you, I am the gate for the sheep. All who came before me are thieves and bandits; but the sheep did not listen to them. I am the gate. Whoever enters by me will be saved, and will come in and go out and find pasture. The thief comes only to steal and kill and destroy. I came that they may have life, and have it abundantly.' "

" 'I am the good shepherd. The good shepherd lays down his life for the sheep. The hired hand, who is not the shepherd and does not own the sheep, sees the wolf coming and leaves the sheep and runs away – and the wolf snatches them and scatters them. The hired hand runs away because a hired hand does not care for the sheep. I am the good shepherd. I know my own and my own know me, just as the Father knows me and I know the Father. And I lay down my life for the sheep. I have other sheep that do not belong to this fold. I must bring them also, and they will listen to my voice. So there will be one flock, one shepherd. For this reason the father loves me, because I lay down my life in order to take it up again. No one takes it from me, but I lay it down of my own accord. I have power to lay it down, and I have power to take it up again. I have received this command from my Father.' "

The inscription below the window is from John 17:11, "And now I am no longer in the world, but they are in the world, and I am coming to you. Holy Father, protect them in your name that you have given me, so that they may be one, as we are one."

Tiffany Studios. Dedicated in 1906 along with the Grapevine window. A memorial to Reverend Francis Hodge.

First Presbyterian Church, Wilkes-Barre ❖ *John 10:1-18, (17:11)* ❖ *The Good Shepherd*

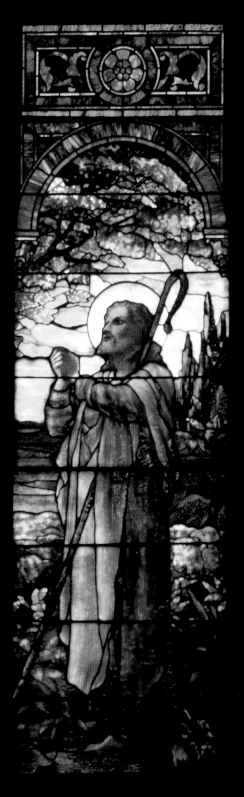

15

The angel symbolizes the holiness of truth in the Christian tradition. John's gospel emphasizes that new life, born of the Spirit which abides in the Word of Jesus, is a life of truth. Truth is thus understood as the interior principle of a good life summed up by such Old Testament phrases as, walking in the truth or doing the truth. Even love of another is seen as loving in the truth through faith. We are called upon to adore God in spirit and in truth, a worship inspired by Jesus' spirit and truth. And finally, truth is expansive. It reaches out. It strains to be told. This is what gave the Apostles and the Church the driving dynamism to go forth and baptize others in the truth of the Gospel. This figure of an angel of truth, therefore, stands as a beacon of hope, direction, support, and protection in the arduous search for living well and spreading the truth of the Gospel.

Tiffany Studios. Installation dates between 1890-1906. A memorial to Reuben Jay Flick (1816-1890). Inscription: "An Honored Deacon of this Church." Also memorial to Margaret Arnold Flick, his wife (1827-1904). This window is the central window in a grouping of stained glass windows. Two circular windows contain the memorial inscription inside wreaths. Two other smaller decorative windows complete the grouping.

First Presbyterian Church, Wilkes-Barre ❖ *Truth Figure*

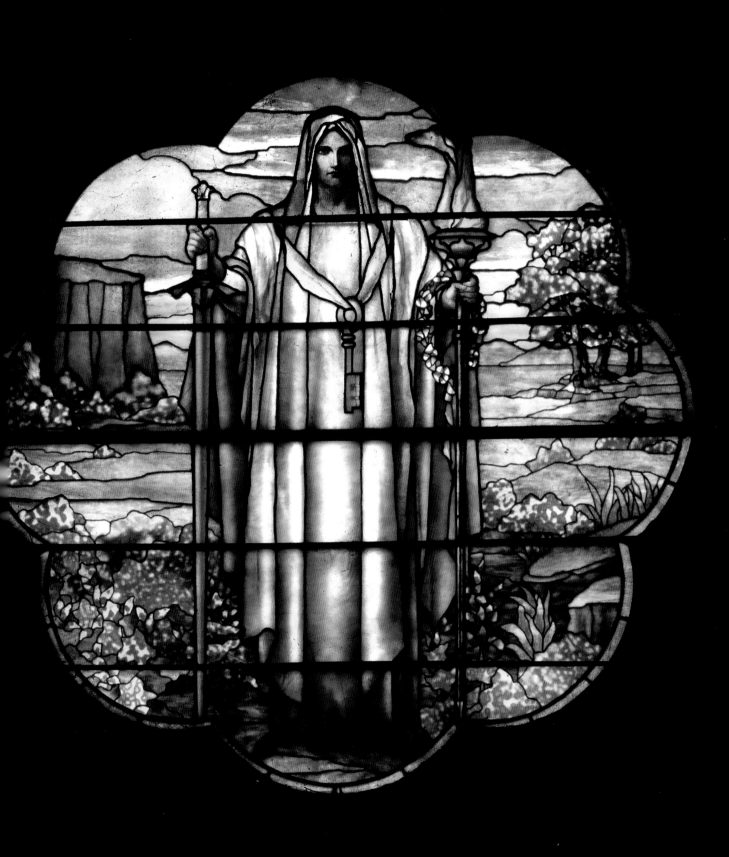

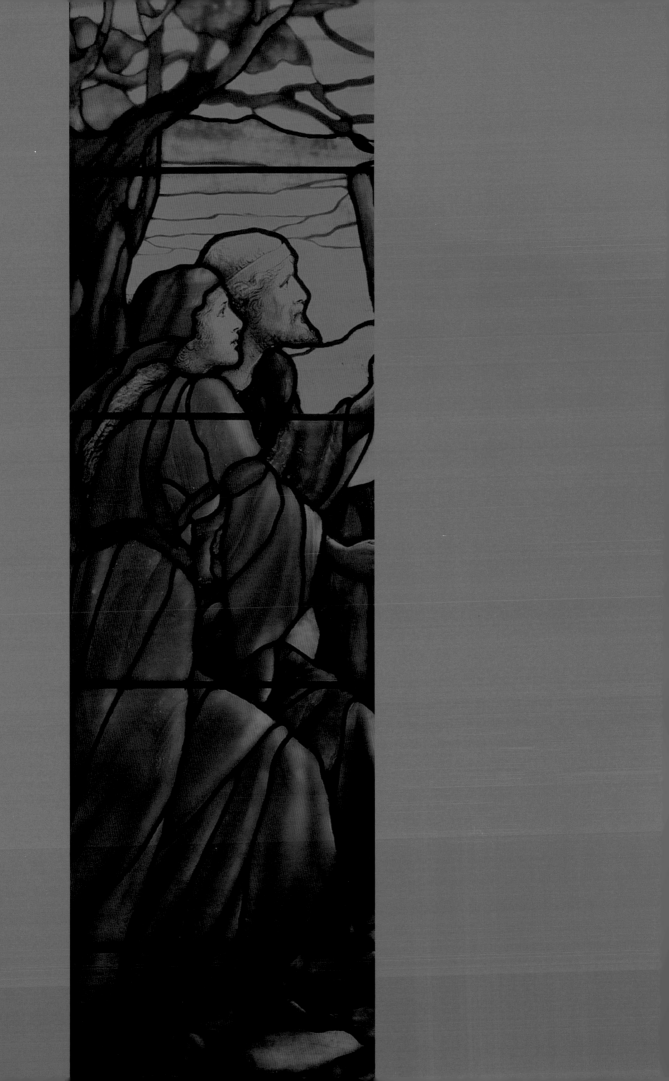

Grace Episcopal Church

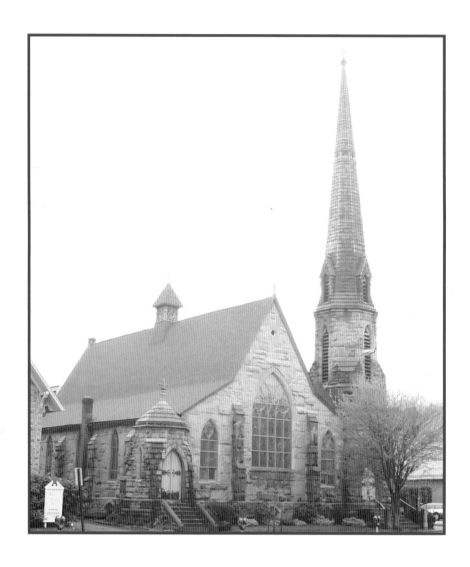

Grace Episcopal Church began in a small church in Honesdale in 1832. In 1854, as the congregation grew in size, it was decided to build a new church in the Gothic Revival style. Willis and Dudley of New York were the architects and Henry Heath the builder. Outstanding stained glass windows with symbolism appear throughout the building. The earliest windows were installed by Doremus of Orange, New Jersey, an important studio of the time, popular with Episcopal patrons. The form of the windows are a paired-lancet type with a simple circular oculus above,

which creates a sense of dialogue between the figures in each side of the lancet. The opalescent stained glass windows date from the turn of the century and were produced by the Tiffany Studios of New York. Other windows are by the Willet Studios of Philadelphia.

The two windows depicted in this book are both by the Tiffany Studios. *Jesus with Two Pilgrims* shows a man and a woman moving up a steep and rocky path to be greeted by Christ. The window was designed by Frederick Wilson and executed in opalescent glass in the Tiffany Studios. Its installation in 1907 coincided with the 75th anniversary of the parish. The window is noted in the commemorative booklet as illustrating the text of John 14:6, "I am the Way, the Truth, and the Life. No man cometh to the Father but by me." The first portion of the verse is inscribed in the base of the panel. The description suggests that the pilgrims are weary from the journey and confronted with apparently insurmountable looming cliffs in front of them. Christ, however, whose head is outlined by a glowing light, assures them that they will be supported by his presence. The color harmonies are compelling, contrasting the blue-gray of the rocks with the russets of the garments, against the mottled blue-green of the sky and trees. Another Tiffany Studios window is recorded as being installed in 1893. Depicting the *Annunciation*, its composition is simpler, and was produced by another designer. Both the Virgin and the angel Gabriel have halos. Behind Gabriel the opalescent glass glows in a sunrise of gold and violet. The Virgin is to the right in darkness, kneeling humbly, seeming to embody her words "Behold the handmaiden of the Lord." The large sections of opalescent glass show the possibilities of the new medium where many different colors were combined in a single sheet.

16

Now the birth of Jesus the Messiah took place in this way. When his mother Mary had been engaged to Joseph, but before they lived together, she was found to be with child from the Holy Spirit. Her husband Joseph, being a righteous man and unwilling to expose her to public disgrace, planned to dismiss her quietly. But just when he had resolved to do this, an Angel of the Lord appeared to him in a dream and said, 'Joseph, son of David, do not be afraid to take Mary as your wife, for the child conceived in her is from the Holy Spirit. She will bear a son, and you are to name him Jesus, for he will save his people from their sins.' All this took place to fulfill what had been spoken by the Lord through the prophet:

> 'Look, the virgin shall conceive
> and bear a son, and they shall
> name him Emmanuel,'

which means, 'God is with us.' When Joseph awoke from sleep, he did as the Angel of the Lord commanded him; he took her as his wife, but had no marital relations with her until she had borne a son; and he named him Jesus."

Church tradition ascribes the window to the Tiffany Studios, designed by Frederick Wilson under the personal supervision of Mrs. Louis Tiffany around 1893. A memorial to Jeremiah Clark Gunn (1804-1889) and Acsah Melissa Griswold (1812-1891).

Grace Episcopal Church, Honesdale ❖ *Matthew: 1:18-25* ❖ *The Annunciation*

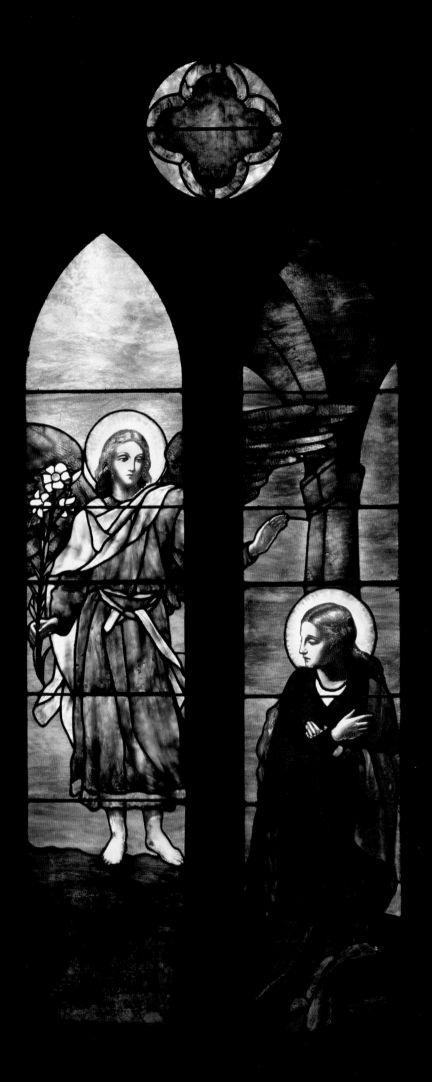

17

his scene of a man and woman disciple approaching Jesus in this setting is not recorded in the Gospels as such, though undoubtedly something like this happened many times. The following passage is based on the inscription below the windows.

"Do not let your hearts be troubled. Believe in God, believe also in me. In my Father's house there are many dwelling places. If it were not so, would I have told you that I go to prepare a place for you? And if I go and prepare a place for you, I will come again and will take you to myself, so that where I am, there you may be also. And you know the way to the place where I am going. Thomas said to him, 'Lord, we do not know where you are going. How can we know the way?' Jesus said to him, 'I am the way, and the truth, and the life. No one comes to the Father except through me. If you know me, you will know my Father also. From now on you do know him and have seen him.'"

Church tradition ascribes this window as having been designed by Frederick Wilson of Tiffany Studios under the supervision of Mrs. Louis Tiffany. Dedicated in 1907 on the occasion of the church's 75th anniversary. A memorial to the glory of God and in loving memory of Annie Russell Dimmick (1843-1906).

Grace Episcopal Church, Honesdale ❖ *John 14:1-7* ❖ *Jesus with two Disciples*

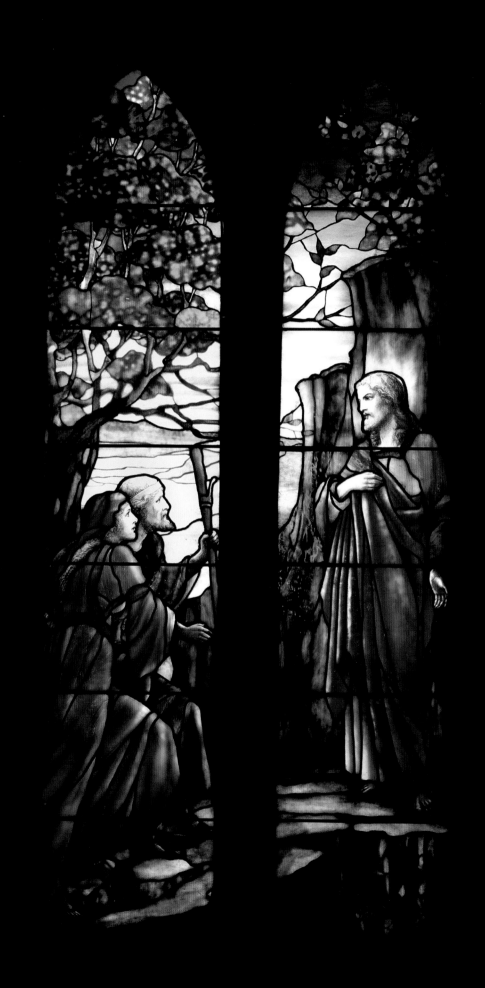

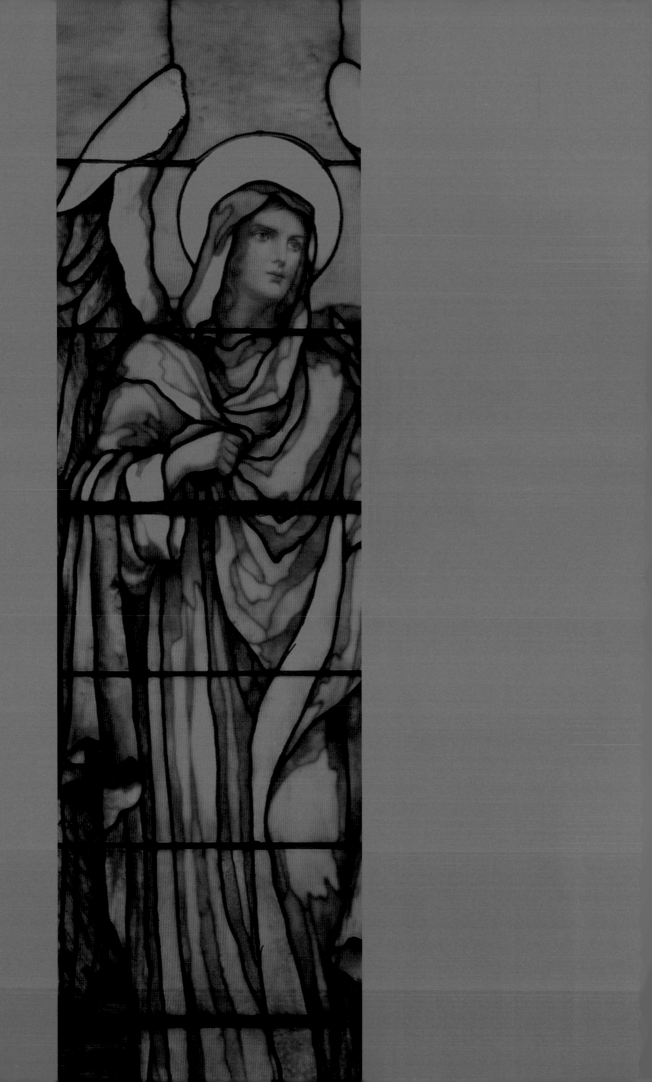

Memorial Presbyterian Church

18
GUARDIAN ANGELS

19 & 20
ANGEL OF THE RESURRECTION 1 & 2

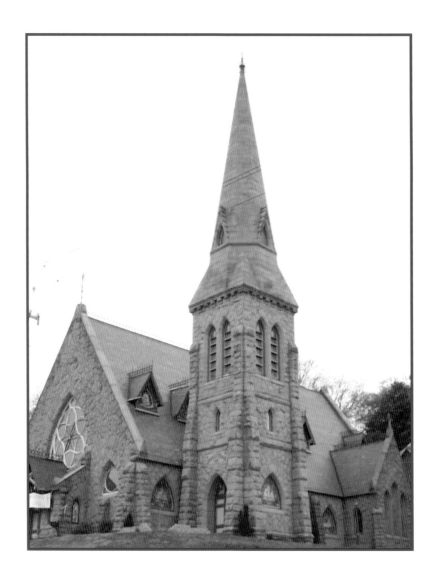

Memorial Presbyterian Church was begun in 1872 and consecrated in 1874. Prior to the construction of the church, the land was the site of an African-American mission, the only one in the Wilkes-Barre area. Calvin Wadhams, one of the laymen who worked in the mission, provided the majority of the funds for the construction of the church, as a memorial to his deceased children. The donor decreed that every tenth pew be exempted from pew rents, thus insuring open access. The style is Gothic,

largely inspired by English precedents. Distinctive features are the rugged stone of the exterior, especially in the entrance porch and the single tower that tapers to an elegant steeple. The interior is open and spacious, crowned by a timber ceiling constructed on the principles of an inverted ship's hull. The windows reflect the history of the church. The windows shown in this book are dedicated to the Wadhams family.

Three windows in the baptismal area to the right of the chancel are dedicated to the Wadhams children. In 1871, scarlet fever swept the area and the three children of Calvin Wadhams and Frances (Fanny) D. Lynde Wadhams all died within 30 days: Mary Catlin, age eight, Lynde Henderson, age six, and Frank Cleveland, age two. The inscriptions are remarkable. In the center under the guardian angel leading Mary, we read: *Their angels do always behold the face of my Father which is in heaven.* To the left the angel descends against a starry sky to greet Lynde: *Clothed in white robes and palms in their hands.* To the right, commemorating the youngest child, Frank, an angel holds a child and flies into a star-strewn sky: *He shall carry the lambs in his bosom.* The windows date from the construction of the church and show brilliant use of enamel and deeply saturated colored glass in the patterned frame. This type of sophisticated work could possibly be by one of the studios of the New York area such as Henry Sharp (1850-1890) or of Philadelphia, such as J. and G. H. Gibson (1837-1900). The two windows in the chancel commemorate, on the left, Calvin Wadhams (1833-1883) and to the right, Frances D. Lynde (1835- 1916). Both windows appear to have been installed shortly after 1916 and present angels with rich drapery and cascading wings. They are executed in the opalescent glass style of variegated colors and plating, especially visible in the drapery.

18

I n the New Testament we find angels closely intertwined with the life of Jesus. At the end of the temptations in the desert we read "Then the devil left him, and suddenly angels came and waited on him" (Matthew 4:11). Later Jesus says "Take care that you do not despise one of these little ones; for, I tell you, in heaven their angels continually see the face of my Father in heaven." (Matthew 18:10-11). "But about that day and hour no one knows, neither the angels in heaven, nor the Son, but only the Father" (Matthew 24:36). But God "will send out his angels with a loud trumpet call, and they will gather his elect from the four winds, from one end of heaven to the other." (Matthew 24:31). "Just so, I tell you, there will be more joy in heaven over one sinner who repents than over ninety-nine righteous persons who need no repentance" (Luke 15:7). Finally, Without any doubt, the mystery of our religion is great:

> "He was revealed in flesh,
> vindicated in spirit
> seen by angels
> proclaimed among Gentiles,
> believed in throughout the world
> taken up in glory." (I Timothy 3:16)

Installed 1874. Possibly fabricated by Henry Sharp Studios of New York City or J. & G. H. Gibson Studios of Philadelphia. A memorial to three children with an inscription for each: Lynde Henderson (1864-1871): "Clothed with white robes and palms in their hands." Mary Catlin (1862-1871): "Their angels do always behold the face of my father which is in heaven." And Frank Cleveland (1868-1871): "He shall carry the lambs in his bosom." On a stone inscription beneath the window we find additional information about the children of Calvin Wadhams and Frances Delphine Lynde Wadhams, all of whom were victims of a scarlet fever epidemic in the area. The entire Baptismal area in the church, where these windows are located, is dedicated to the children.

Memorial Presbyterian Church, Wilkes-Barre ❖ *Guardian Angels*

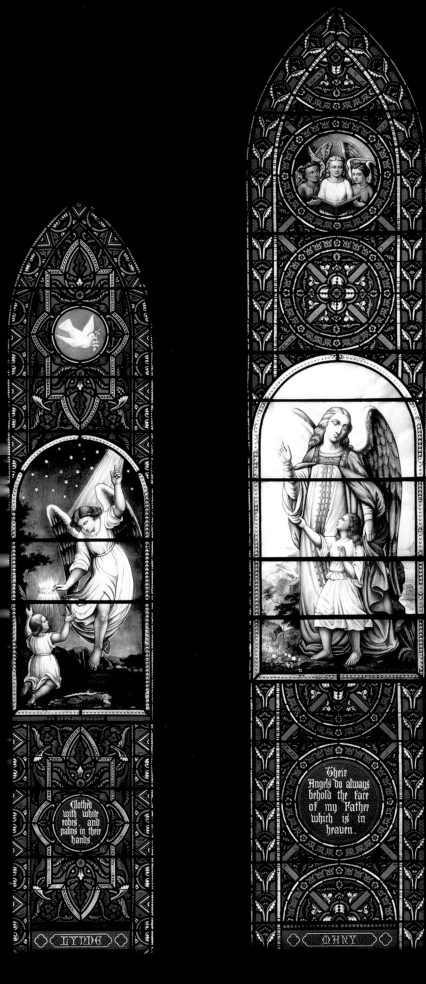

Clothed
with white
robes and
palms in their
hands.

Their
Angels do always
behold the face
of my Father
which is in
heaven.

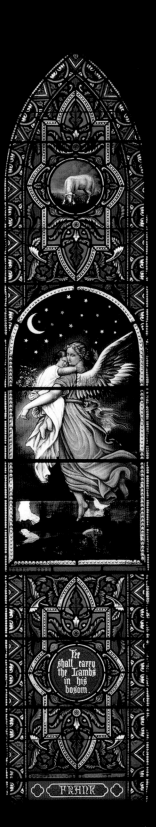

He
shall carry
the Lambs
in his
bosom.

LYNDE

MARY

FRANK

19·20

Then I turned to see whose voice it was that spoke to me, and on turning I saw seven golden lampstands, and in the midst of the lampstands I saw one like the Son of Man, clothed with a long robe and with a golden sash across his chest. His head and his hair were white as white wool, white as snow; his eyes were like a flame of fire, his feet were like burnished bronze, refined as in a furnace, and his voice was like the sound of many waters. In his right hand he held seven stars, and from his mouth came a sharp, two-edged sword, and his face was like the sun shining with full force."

"Then I looked, and I heard the voice of many angels surrounding the throne and the living creatures and the elders; they numbered myriads and myriads and thousands of thousands, singing with full voice,

'Worthy is the Lamb that was slaughtered to receive power and wealth and wisdom and might and honor and glory and blessing!' "

"Then I heard every creature in heaven and on earth and under the earth and in the sea, and all that is in them, singing,

'To the one seated on the throne and to the lamb be blessing and honor and glory and might forever and ever!' "

"And the four living creatures said 'Amen!' And the elders fell down and worshiped."

"When the lamb opened the seventh seal, there was silence in heaven for about half an hour. And I saw the seven Angels who stand before God, and seven trumpets were given to them. Another angel with a golden censer came and stood at the altar; he was given a great quantity of incense to offer with the prayers of all the saints on the golden altar that is before the throne. And the smoke of the incense, with the prayers of the saints, rose before God from the hand of the angel. Then the angel took the censer and filled it with fire from the altar and threw it on the earth; and there were peals of thunder, rumblings, flashes of lightning, and an earthquake."

Installed in 1916, the memorial on the left is to Calvin Wadhams (1833-1883). He is described as "The Founder of this Church." The memorial on the right is to Frances Delphine Lynde Wadhams (1833-1916). The windows have a memorial panel below and a triangular arch above that are not included in the photograph.

Memorial Presbyterian Church, Wilkes-Barre ❖ *Revelation 1:12-16; 5:11-14; 8:1-5*
Angel of the Resurrection 1 and 2

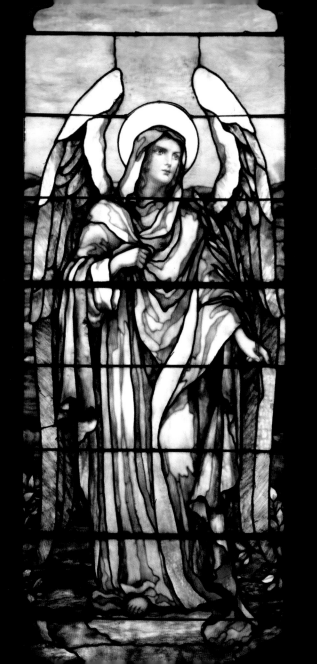
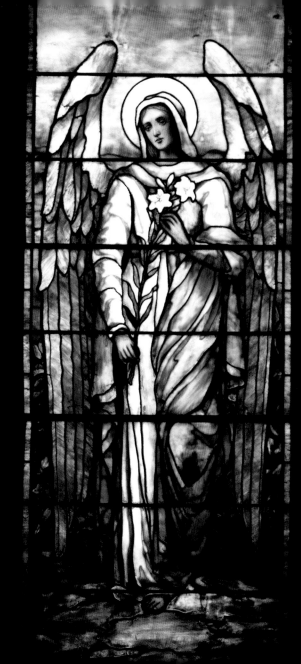

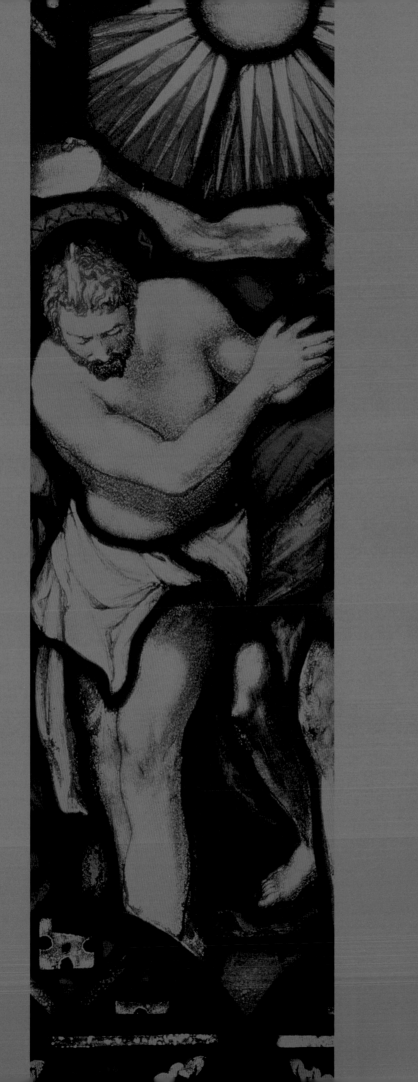

Nativity Church

The Church of the Nativity is located in Scranton's South Side. Its dome dominates the landscape, especially as seen across the Roaring Brook ravine. It is typical of the phased construction of Catholic churches at the time. The basement was built and consecrated in 1905, while the upper portions were only completed in 1912-1914. Reverend Dr. J. J. Loughran was the pastor, and Charles E. Birge, of New York, served as architect. The church is built in a Gothic style with a wide nave, prominent transept, and an octagonal dome carried on Byzantine-style pendentives over the crossing. Its exterior is made of rusticated stone. Its facade has two symmetrical square towers, open at the top, which flank the entrance. Large multi-sectioned windows are located in the facade and the ends of the transepts. The five *Joyful Mysteries of the Rosary* appear in the wall of the left transept. Surrounding a large *Nativity*, the name of the church, are

scenes of the *Annunciation, Visitation, Presentation in the Temple*, and the *Finding of the Boy Jesus in the Temple*. In the facing wall, we find the five *Sorrowful Mysteries*. Surrounding the *Crucifixion* (shown in this book), are the *Agony in the Garden, Flagellation, Mocking of Christ*, and *Christ Carrying the Cross*. The entrance wall contains the windows depicting the *Glorious Mysteries*, which include the *Resurrection, Ascension, Pentecost, Assumption*, and the *Coronation of the Blessed Virgin Mary*. These last two were given by Rev. J. J. Loughran, evidence of the pastor's particular devotion to the Blessed Virgin. The *Glorious Mysteries* windows are shown in this book.

The commissions list from the Franz Zettler Studio of Munich for Scranton cites the windows of 1910-1912 ordered by Rev. J. J. Dr. Loughan (sic). These are clearly for the Church of the Nativity since it was under construction at the time. Since the early years of the Zettler firm were chronicled by Josef Fischer in 1910, this was a bit too early to include a commission for the Church of the Nativity.

The architectural canopies at the top and bottom of the windows were familiar to artist and audience alike because of the widespread medieval precedents such as those in Cologne cathedral in the Rhineland, the Church of St. Thomas in Strasbourg, the Regensburg cathedral in Bavaria, or the Heiligenkreuz in Austria. Nativity Church show Gothic inspiration in the architectural frame, but a three-dimensional Renaissance inspiration in the figural grouping. Brilliant draftsmanship can be seen in the windows as, for example, the handling of anatomy in the solders who are falling back as Christ steps out of the tomb. Distinguishing characteristics of the firm are: the delicacy of modeling seen in the faces and the volumetric rendering of the garments seen in Christ's red cloak or the robe that swirls around the Virgin of the *Assumption*.

21

When the day of Pentecost had come, they were all together in one place. And suddenly from heaven there came a sound like the rush of a violent wind, and it filled the entire house where they were sitting. Divided tongues, as of fire, appeared among them, and a tongue rested on each of them. All of them were filled with the Holy Spirit and began to speak in other languages, as the Spirit gave them ability."

"Now there were devout Jews from every nation under heaven living in Jerusalem. And at this sound the crowd gathered and was bewildered, because each one heard them speaking in the native language of each. Amazed and astonished, they asked, 'Are not all these who are speaking Galileans? And how is it that we hear, each one of us, in our own native language? Parthians, Medes, Elamites, and residents of Mesopotamia, Judea and Cappadocia, Pontus and Asia, Phrygia and Pamphylia, Egypt and the parts of Libya belonging to Cyrene, and visitors from Rome, both Jews and proselytes, Cretans and Arabs — in our own languages we hear them speaking about God's deeds of power.' All were amazed and perplexed, saying to one another, 'What does this mean?' But others sneered and said, 'They are filled with new wine.' But Peter, standing with the eleven, raised his voice and addressed them, 'Men of Judea and all who live in Jerusalem, let this be known to you, and listen to what I say. Indeed, these are not drunk, as you suppose, for it is only nine o'clock in the morning. No, this is what was spoken through the prophet Joel:'

'In the last days it will be, God declares,
 that I will pour out my Spirit upon all flesh,
 and your sons and your daughters shall prophesy,
 and your young men shall see visions,
 and your old men shall dream dreams.' "

Designed by Zettler Studios of Munich, Germany. Installed in 1914. This window was the gift of Mr. and Mrs. Thomas F. Quinn who also gave the "Resurrection" window. These two windows are in a set of six windows at the entrance of the church which depict the "Glorious Mysteries of the Rosary."

Nativity Church, Scranton ❖ *Acts 2:1-17* ❖ *Pentecost*

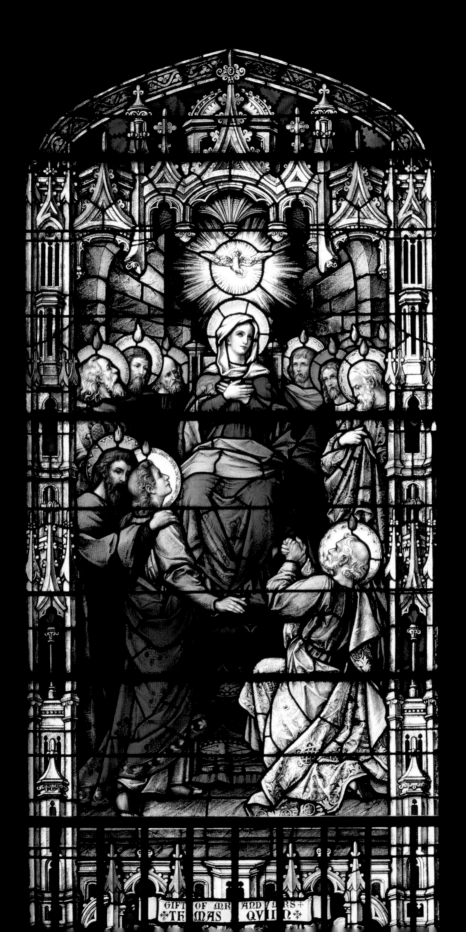

GIFT OF MR AND MRS
THOMAS QUIN

This scene of Mary's crowning in heaven symbolizes a mother's influence on her son, Jesus. One with him during his earthly life, through his suffering and death, she is now one with him in his resurrection. She now shares with him his heavenly life. Her "crowning" shows her to us as our intercessor with her son since it was through her that her son became our brother.

"Then the twenty four elders who sit on their thrones before God fell on their faces and worshiped God, singing,

'We give you thanks, Lord God Almighty,
who are and who were, for you have taken your
great power and begun to reign.
The nations raged, but your wrath has come
and the time for judging the dead,
for rewarding your servants, the prophets
and saints and all who fear your name,
both small and great, and for destroying
those who destroy the earth.' "

"A great portent appeared in heaven: a woman clothed with the sun, with the moon under her feet, and on her head a crown of twelve stars. She was pregnant and was crying out in birthpangs, in the agony of giving birth. Then another portent appeared in heaven, a great red dragon, with seven heads and ten horns, and seven diadems on his heads. His tail swept down a third of the stars of heaven and threw them to the earth. Then the dragon stood before the woman who was about to bear a child, so that he might devour her child as soon as it was born. And she gave birth to a son, a male child, who is to rule all the nations with a rod of iron. But her child was snatched away and taken to God and to his throne; and the woman fled into the wilderness, where she has a place prepared by God."

> *Designed by Zettler Studios of Munich, Germany. Installed in 1914.*
> *This window, as well as the "Assumption" window was the gift of Reverend J. J.*
> *Loughran, D.D., who was pastor of Nativity Church from 1907 to 1940.*
> *These windows are two of the series of six windows showing the*
> *"Glorious Mysteries of the Rosary."*

Nativity Church, Scranton ❖ *Revelation: 11:16-19; 12:1-6a* ❖ *The Coronation of Mary*

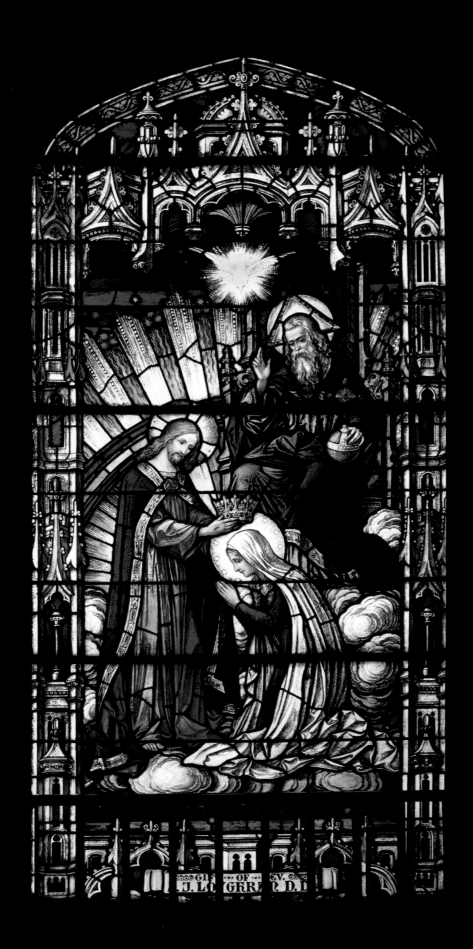

GIFT OF REV.
J. L... GRR... D.D.

23

This Resurrection window is different from those based on the Gospel narratives, in that it portrays the moment of Christ's rising. One soldier guarding the tomb is asleep, while the other one seems to be kneeling before Christ. While there is a small angel in the right background, the figure of Christ dominates the center of the window. Here is a second resurrection narrative, this time Mark's, which describes a later moment when the women find the empty tomb:

"When the Sabbath was over, Mary Magdalene, and Mary the mother of James, and Salome, bought spices, so that they might go and anoint him. And very early on the first day of the week, when the sun had risen, they went to the tomb. They had been saying to one another, 'Who will roll away the stone for us from the entrance to the tomb?' When they looked up they saw that the stone, which was very large, had already been rolled back. As they entered the tomb, they saw a young man, dressed in a white robe, sitting on the right side; and they were alarmed. But he said to them, 'Do not be alarmed; you are looking for Jesus of Nazareth, who was crucified. He has been raised; he is not here. Look, there is the place they laid him. But go, tell his disciples and Peter that he is going ahead of you to Galilee; there you will see him, just as he told you.' So they went out and fled from the tomb, for terror and amazement had seized them; and they said nothing to anyone, for they were afraid."

Designed by Zettler Studios of Munich, Germany. Installed in 1914.
The gift of Mr. and Mrs. P.A. Cavanaugh, who also donated another
one of the "Glorious Mystery" windows.

Nativity Church, Scranton ❖ *Mark 16:1-8* ❖ *The Resurrection*

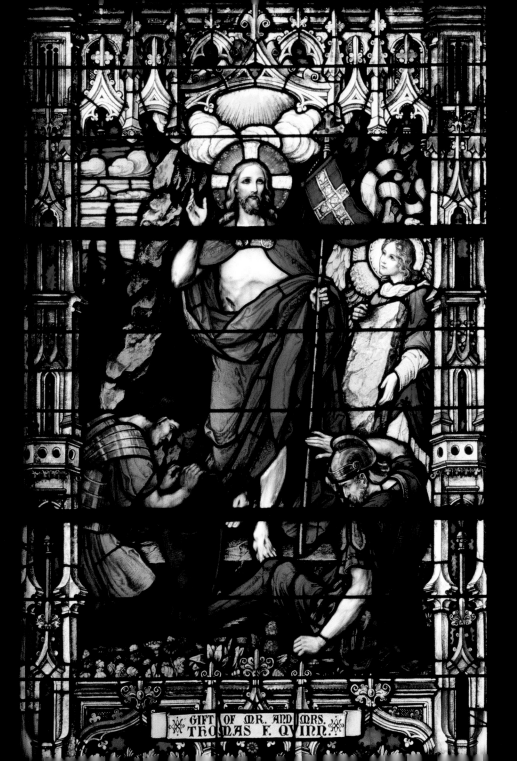

GIFT OF MR. AND MRS.
THOMAS F. QUINN

24

Later he appeared to the eleven themselves as they were sitting at the table; and he upbraided them for their lack of faith and stubbornness, because they had not believed those who saw him after he had risen. And he said to them, 'Go into all the world and proclaim the good news to the whole creation. The one who believes and is baptized will be saved; but the one who does not believe will be condemned. And these signs will accompany those who believe: by using my name they will cast out demons; they will speak in new tongues; . . . they will lay their hands on the sick, and they will recover.' "

"So then the Lord Jesus, after he had spoken to them, was taken up into heaven and sat down at the right hand of God. And they went out and proclaimed the good news everywhere, while the Lord worked with them and confirmed the message by the signs that accompanied it."

Designed by Zettler Studios of Munich, Germany. Installed in 1914.
A memorial to Mr. and Mrs. Thomas F. Quinn.

Nativity Church, Scranton ❖ *Mark 16:14-20* ❖ *The Ascension*

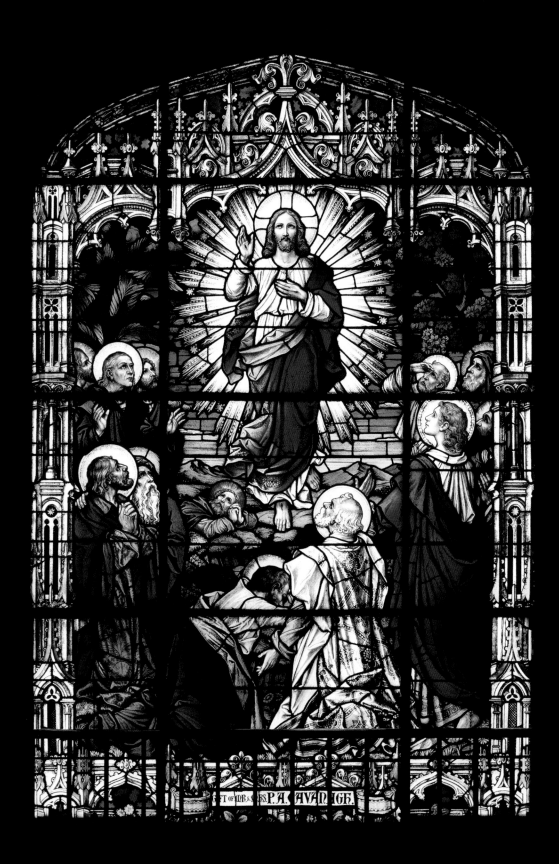

25

The church tells us that the mystery of Mary's motherhood of Jesus implies full unity with the mystery of Jesus' own life, his growing up, his public life, and his death on the cross. It also implies unity with his resurrection as seen in her Assumption. And so, this union is often portrayed, as here, by a Mary glorified in the heavenly Jerusalem. It is, of course, not merely a private honor. It is the public recognition of the central role she played in Jesus' saving life, and an affirmation of her power of mediation with him, who is the Son of God, himself both brother of, and mediator for, all mankind.

Designed by Zettler Studios of Munich, Germany. Installed in 1914. This window, as well as the "Coronation of Mary" window, was the gift of Reverend John J. Loughran. They are two of the series of six windows showing the "Glorious Mysteries of the Rosary."

Nativity Church, Scranton ❖ *Assumption*

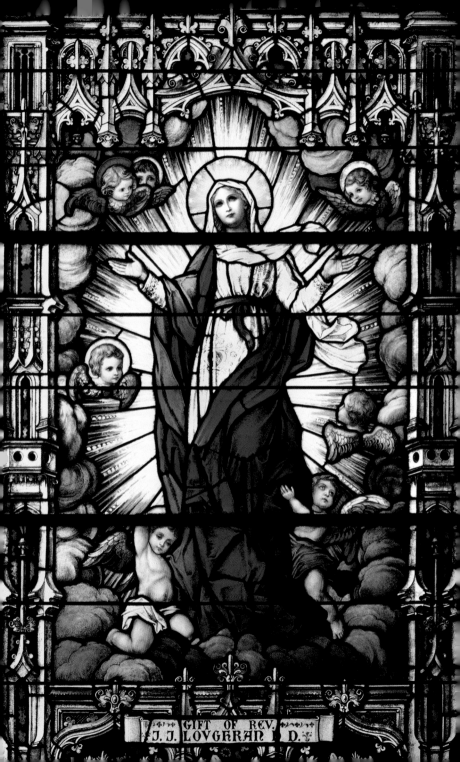

GIFT OF REV.
J. J. LOVGHRAN ᴰ D.

26

In the time of King Herod, after Jesus was born in Bethlehem of Judea, wise men from the East came to Jerusalem, asking, 'Where is the child who has been born king of the Jews? For we observed his star at its rising, and have come to pay him homage.' When King Herod heard this, he was frightened, and all Jerusalem with him; and calling together all the chief priests and scribes of the people, he inquired of them where the Messiah was to be born. They told him, 'In Bethlehem of Judea; for so it has been written by the prophet:'

> 'And you, Bethlehem, in the land
> of Judah,
> are by no means least among
> the rulers of Judah;
> for from you shall come a ruler
> who is to shepherd my
> people Israel.' "

"Then Herod secretly called for the wise men and learned from them the exact time when the star had appeared. Then he sent them to Bethlehem, saying, 'Go and search diligently for the child; and when you have found him, bring me word so that I may also go and pay him homage.' When they had heard the king, they set out; and there, ahead of them, went the star that they had seen at its rising, until it stopped over the place where the child was. When they saw that the star had stopped, they were overwhelmed with joy. On entering the house, they saw the child with Mary his mother; and they knelt down and paid him homage. Then, opening their treasure chests, they offered him gifts of gold, frankincense, and myrrh. And having been warned in a dream not to return to Herod, they left for their own country by another road."

Attributed to the D'Ascenzo Studio, Philadelphia. Installed around 1912. It is a small window (14" by 24"), located in the entrance of the left tower alongside the "Flight into Egypt" window.

Nativity Church, Scranton ❖ *Matthew 2:1-12* ❖ *Adoration of the Magi*

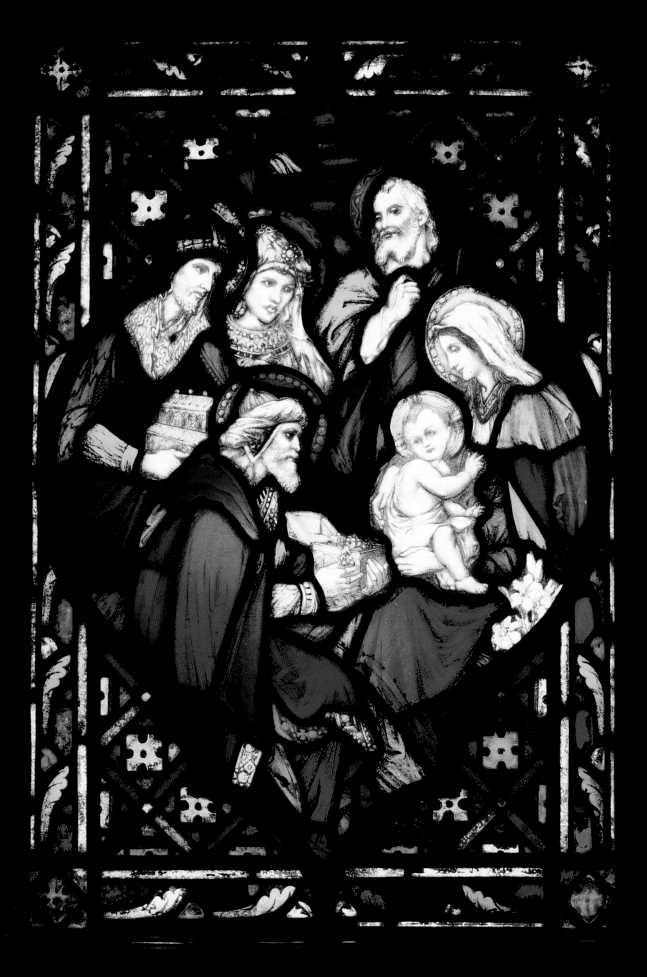

27

Now after they had left, an angel of the Lord appeared to Joseph in a dream and said, 'Get up, take the child and his mother, and flee to Egypt, and remain there until I tell you; for Herod is about to search for the child, to destroy him.' Then Joseph got up, took the child and his mother by night, and went to Egypt, and remained there until the death of Herod. This was to fulfill what had been spoken by the Lord through the prophet, 'Out of Egypt I have called my son.' "

"When Herod saw that he had been tricked by the wise men, he was infuriated, and he sent and killed all the children in and around Bethlehem who were two years old or under, according to the time that he had learned from the wise men. Then was fulfilled what had been spoken through the prophet Jeremiah:

'A voice was heard in Ramah,
wailing and loud lamentation,
Rachel weeping for her children;
she refused to be consoled,
because they are no more.' "

"When Herod died, an angel of the Lord suddenly appeared in a dream to Joseph in Egypt and said, 'Get up, take the child and his mother, and go to the land of Israel, for those who were seeking the child's life are dead.' Then Joseph got up, took the child and his mother, and went to the land of Israel. But when he heard that Archelaus was ruling over Judea in place of his father Herod, he was afraid to go there. And after being warned in a dream, he went away to the district of Galilee. There he made his home in a town called Nazareth, so that what had been spoken through the prophets might be fulfilled, 'He will be called a Nazorean.' "

Attributed to the D'Ascenzo Studio, Philadelphia. Installed around 1912. It is a small window (14" x 24") located in the entrance of the left tower alongside the "Adoration of the Magi" window.

Nativity Church, Scranton ❖ *Matthew 2:13-23* ❖ *Flight into Egypt*

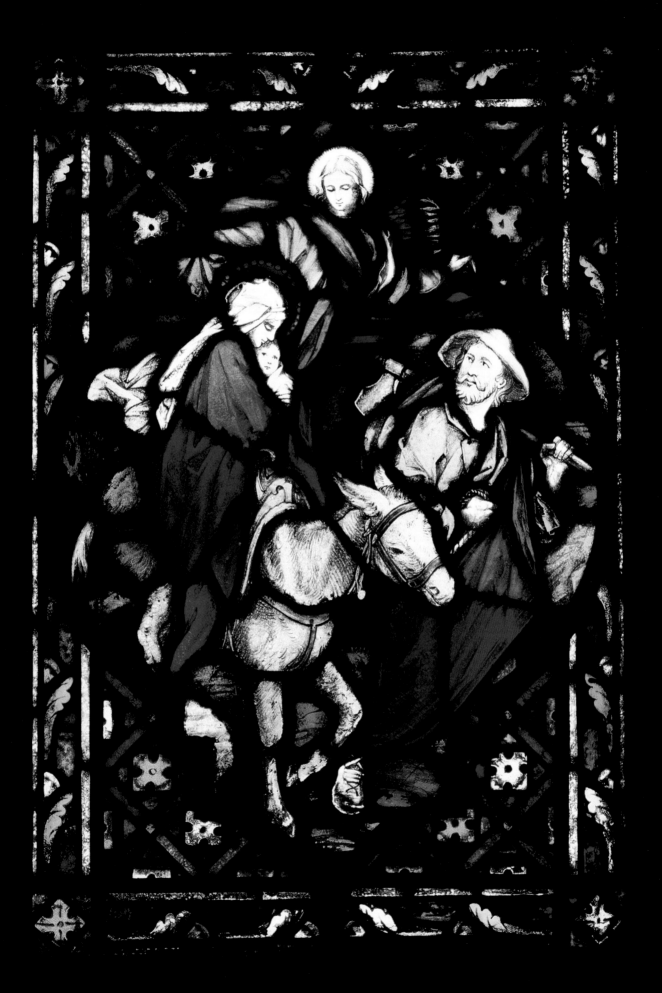

28

n those days John the Baptist appeared in the wilderness of Judea, proclaiming, 'Repent, for the kingdom of heaven has come near.' This is the one of whom the prophet Isaiah spoke when he said,

'The voice of one crying out in
the wilderness:
prepare the way of the Lord,
make his paths straight.' ”

“ 'I baptize you with water for repentance, but one who is more powerful than I is coming after me; I am not worthy to carry his sandals. He will baptize you with the Holy Spirit and fire. His winnowing fork is in his hand, and he will clear his threshing floor and will gather his wheat into the granary; but the chaff he will burn with unquenchable fire.' ”

“Then Jesus came from Galilee to John at the Jordan, to be baptized by him. John would have prevented him, saying, 'I need to be baptized by you, and do you come to me?' But Jesus answered him, 'Let it be so now; for it is proper for us in this way to fulfill all righteousness.' Then he consented. And when Jesus had been baptized, just as he came up from the water, suddenly the heavens were opened to him and he saw the Spirit of God descending like a dove and alighting on him. And a voice from heaven said, 'This is my Son, the Beloved, with whom I am well pleased.' ”

Attributed to the D'Ascenzo Studio, Philadelphia. Installed around 1912.
It is a small window (14" x 24.") located in entrance of the right tower,
alongside the "Resurrected Jesus" window.

Nativity Church, Scranton ❖ *Matthew 3:1-3; 11-17* ❖ *Baptism of the Lord*

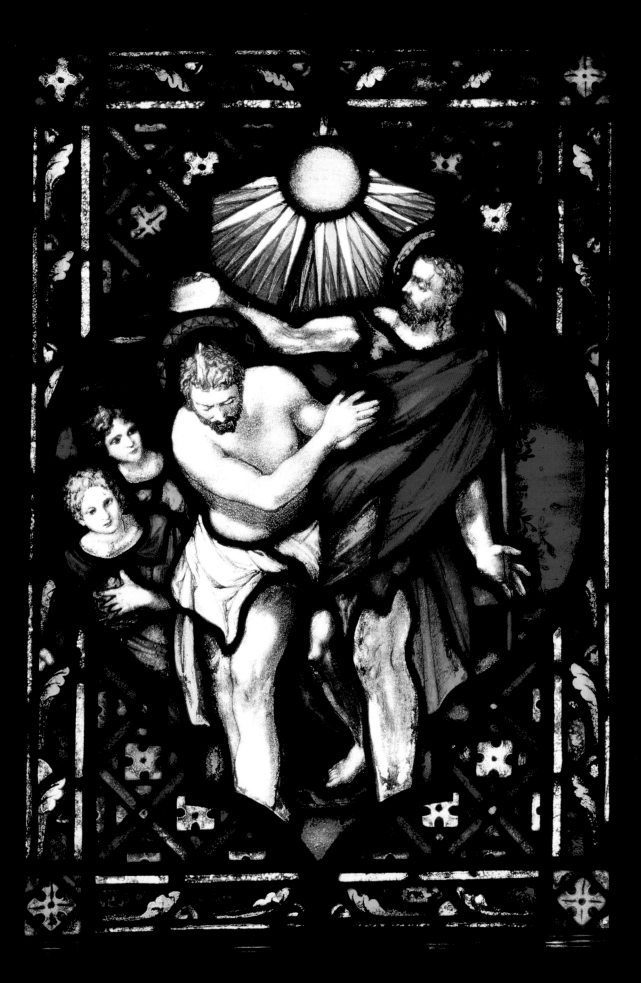

29

The scene is the final appearance of the risen Christ to his disciples by the lake of Galilee as given in the Gospel of John. It was after they had eaten with Jesus on the shore that he asked Peter three times, "Do you love me?" And Peter answered three times, (cancelling out his triple denial in the High Priest's courtyard), "Lord, you know everything. You know that I love you." At the end of this meal and conversation, Jesus said: "Follow me."

"Peter turned and saw the disciple whom Jesus loved following them; he (John) was the one who had reclined next to Jesus at the supper and had said, 'Lord, who is it that is going to betray you?' When Peter saw him, he said to Jesus, 'Lord, what about him?' Jesus said to him, 'If it is my will that he remains until I come, what is that to you? Follow me!' So the rumor spread in the community that this disciple would not die. Yet Jesus did not say to him that he would not die, but, 'If it is my will that he remain until I come, what is that to you?' "

"This is the disciple who is testifying to these things and has written them, and we know that his testimony is true. But there are also many other things that Jesus did; if every one of them were written down, I suppose that the world itself could not contain the books that would be written."

Attributed to the D'Ascenzo Studio, Philadelphia. Installed around 1912. It is a small window (14" x 24") located in left entrance on the right tower alongside the "Baptism of Jesus" window.

Nativity Church, Scranton ❖ *John 21:20-25* ❖ *Resurrected Jesus with Saints Peter and John*

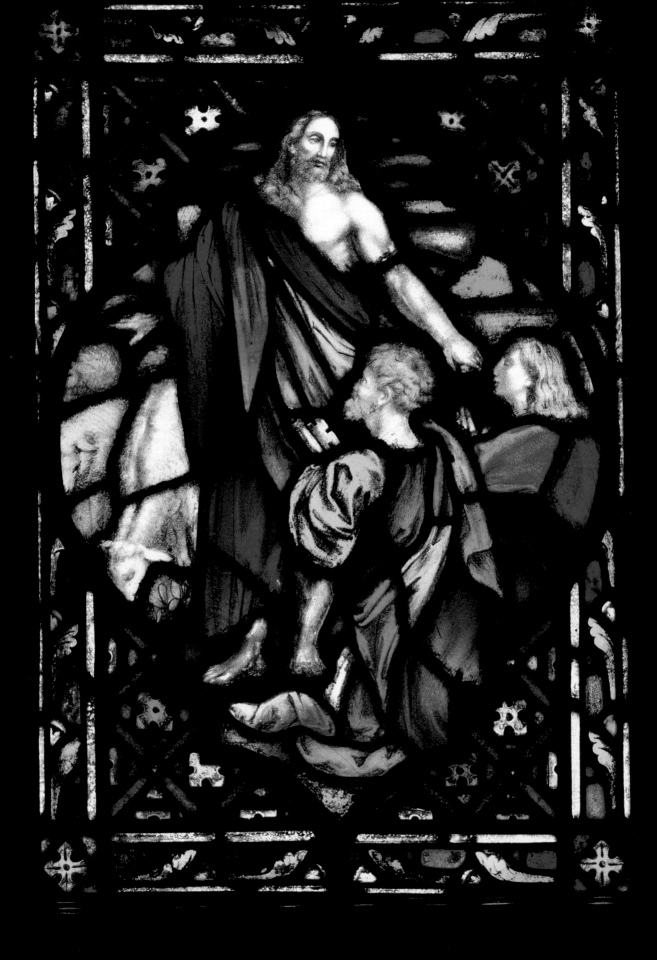

30

So they took Jesus; and carrying the cross by himself, he went out to what is called The Place of the Skull, which in Hebrew is called Golgotha. There they crucified him, and with him two others, one on either side, with Jesus between them. Pilate also had an inscription written and put on the cross. It read, 'Jesus of Nazareth, the King of the Jews.' Many of the Jews read this inscription, because the place where Jesus was crucified was near the city; and it was written in Hebrew, in Latin, and in Greek. Then the chief priests of the Jews said to Pilate, 'Do not write, The King of the Jews,' but, 'This man said, "I am King of the Jews."' Pilate answered, 'What I have written I have written.' When the soldiers had crucified Jesus, they took his clothes and divided them into four parts, one for each soldier. They also took his tunic; now the tunic was seamless, woven in one piece from the top. So they said to one another, 'Let us not to tear it, but cast lots for it to see who will get it.' This was to fulfill what the scripture says,

'They divided my clothes among themselves
and for my clothing they cast lots.'"

"And that is what the soldiers did."

"Meanwhile, standing near the cross of Jesus were his mother, and his mother's sister, Mary the wife of Clopas, and Mary Magdalene. When Jesus saw his mother and the disciple whom he loved standing beside her, he said to his mother, 'Woman, here is your son.' Then he said to the disciple, 'Here is your mother.' And from that hour the disciple took her into his own home."

"After this, when Jesus knew that all was now finished, he said (in order to fulfill the scripture), 'I am thirsty.' A jar full of sour wine was standing there. So they put a sponge full of the wine on a branch of hyssop and held it to his mouth. When Jesus had received the wine, he said, 'It is finished.' Then he bowed his head and gave up his spirit."

Designed by Zettler Studio, Munich, Germany. Installed in 1914 in the wall of the right transept along with the other "Sorrowful Mysteries of the Rosary" windows. The "Crucifixion" is the largest window of the set and is centered in the middle of the four other windows showing "Christ's Passion: The Agony in the Garden," "Flagellation," "Mocking of Christ," and "Christ Carrying the Cross." Gift of Hubert Gordon.

Nativity Church, Scranton ❖ *John 19:17-30* ❖ *The Crucifixion*

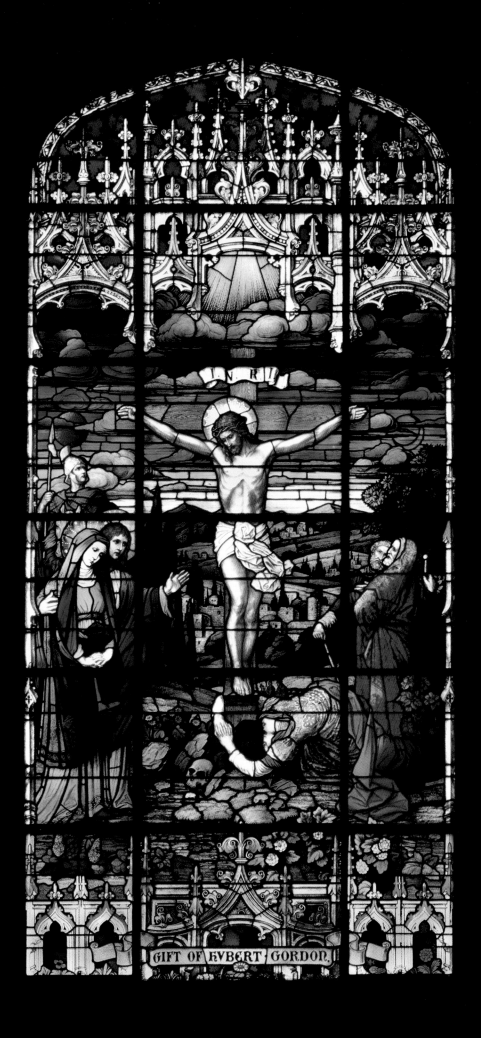

GIFT OF HVBERT GORDON.

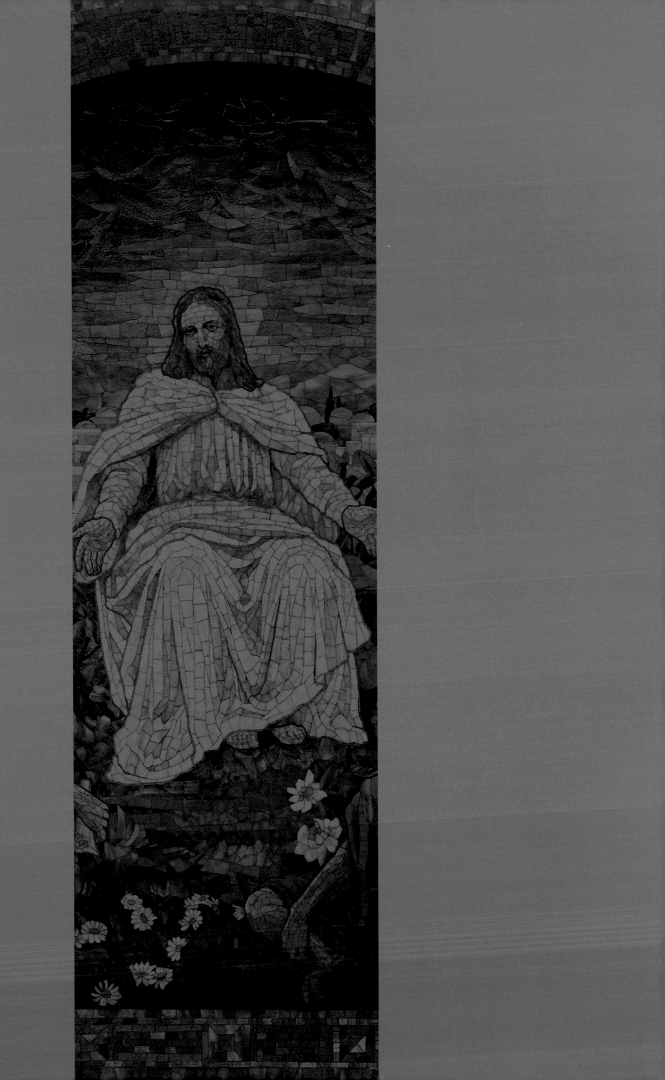

SMURFIT ARTS CENTER

31
CHRIST THE TEACHER

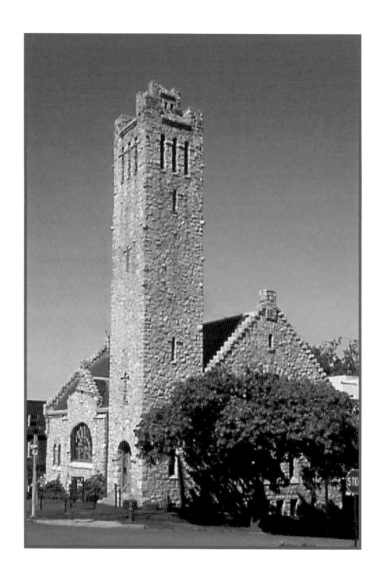

The John Raymond Memorial Church, Universalist, at the corner of Madison and Vine streets in downtown Scranton is now the Smurfit Arts Center, of University of Scranton. It was dedicated in 1906. The style is known as the "picturesque" Romanesque Revival, and includes a massive, squarish single tower. The round-arched style was one particularly favored

by less ritualistic churches, such as the Unitarian, the Baptist, or the Congregational. The building emphasizes natural material, from the rusticated stonework of the exterior, to the original interior. Its quarter oak pews have warm, brown tones. The mosaic in the chancel, planned from the outset, appears to have been the only image in the building. The stained glass in the large windows is of an abstract pattern. Placed in the church in time for Easter 1906, the mosaic shows Christ seated in a wooded landscape. The figures gathered around him appear to be the Apostles as well as a boy and a girl. The following indicate that the mosaic was produced by Tiffany Studios: its opalescent, variegated colors, the foil-backed gold tesserae (the mosaic sections), and the strong facial and compositional similarities to those of Tiffany's designer, Frederick Wilson. Haloes are not used, but Christ is in white and a glow does appear behind his head. An inscription around the edge: *Know the truth and the truth will make you free* suggests the importance of freedom of inquiry to Unitarian/Universalist thinking. The image was referred to from the first news reports on the church as the "Sermon on the Mount."

31

h e came down with them and stood on a level place, with a great crowd of his disciples and a great multitude of people from Judea, Jerusalem, and the coast of Tyre and Sidon. They had come to hear him and be healed of their diseases; and those who were troubled with unclean spirits were cured. And all in the crowd were trying to touch him, for power came out from him and healed all of them. Then he looked up at his disciples and said:

'Blessed are you who are poor, for yours is the kingdom of God.'

'Blessed are you who are hungry now, for you will be filled.'

'Blessed are you who weep now for you will laugh.'

'Blessed are you when people hate you, and when they exclude you, revile you, and defame you on account of the Son of Man. Rejoice in that day and leap for joy, for surely your reward is great in heaven; for that is what their ancestors did to the prophets.'

'But woe to you who are rich, for you have received your consolation.'

'Woe to you who are full now, for you will be hungry.'

'Woe to you who are laughing now, for you will mourn and weep.'

Woe to you when all speak well of you, for that is what their ancestors did to the false prophets.'

'But I say to you that listen, Love your enemies, do good to those who hate you, bless those who curse you, pray for those who abuse you. If anyone strikes you on the cheek, offer the other also; and from anyone who takes away your coat do not withhold even your shirt. Give to everyone who begs from you; and if anyone takes away your goods, do not ask for them again. Do to others as you would have them do to you.'

'If you love those who love you, what credit is that to you? For even sinners love those who love them. If you do good to those who do good to you, what credit is that to you? For even sinners do the same. If you lend to those from whom you hope to receive, what credit is that to you? Even sinners lend to sinners, to receive as much again. But love your enemies, do good, and lend, expecting nothing in return. Your reward will be great, and you will be children of the Most High; for he is kind to the ungrateful and the wicked. Be merciful just as your Father is merciful.' "

The style of Frederick Wilson, designer for Tiffany Studios. An article that appeared on January 4, 1906 said that a mosaic on the "Sermon on the Mount" was to be installed on Easter, 1906. Memorial to John Raymond, commemorating the John Raymond Universalist Church. The inscription around the arching periphery reads, "Know the Truth and the Truth Will Make You Free." The church closed many years ago and is now an art center for the University of Scranton.

Smurfit Arts Center, Scranton (former church) ❖ *Luke 6:17-36* ❖ *Christ the Teacher*

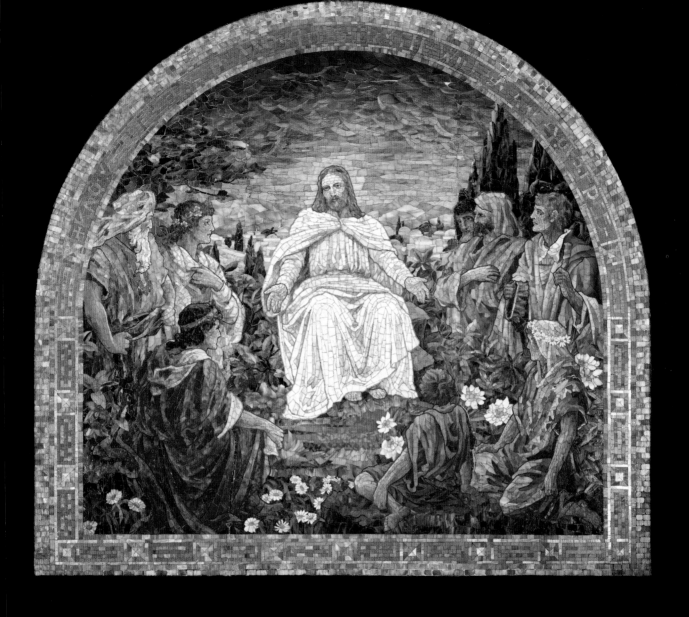

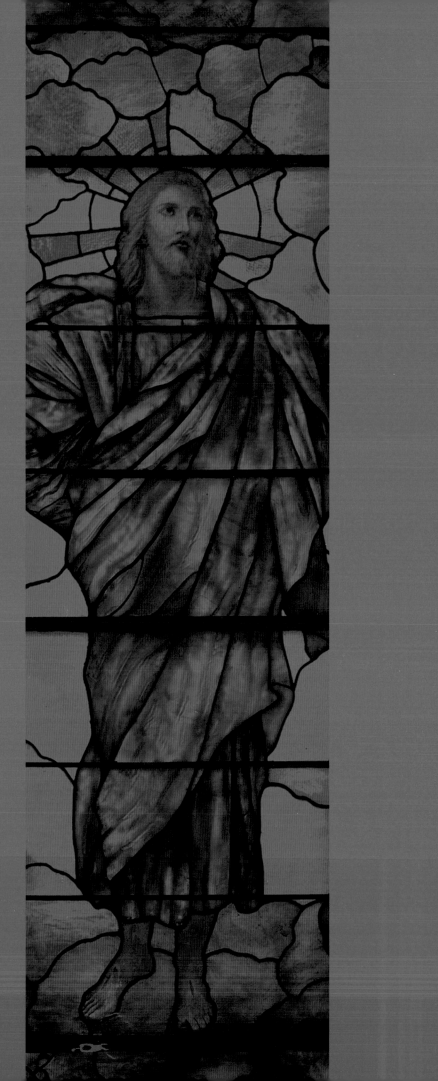

St. Luke's Episcopal church

St. Luke's Church on Wyoming Avenue in downtown Scranton is of both historical and artistic significance. It was built in 1871, according to the plans and designs of the architectural firm of Richard Upjohn, one of the preeminent American Gothic Revival architects of his time. In 1891 a fire severely damaged the chancel, destroying the four original stained glass windows portraying the four evangelists. The chancel was then rebuilt by the Tiffany Decorating Company of New York in similar Gothic style. It was at this time that the large *Ascension* window, with its striking color harmonies of yellow-orange and blue, was installed over the altar. Colors

fuse through its many segments, creating the impression of light shining through the clouds. Christ is in the center, surrounded by light, with angels kneeling at his side, their bodies melding into the blue background. According to church records, the window was installed in 1892, although the chancel renovation lasted from 1891 to 1905. Another 1910 Tiffany Studios window of the *Nativity* was installed in 1916. Mary gazing lovingly at the sleeping Christ child is an appropriate theme for a window dedicated to a mother. The domes on the low middle eastern buildings were created by etching on the exterior of the glass with acid. Framing this realistic scene is a more abstract Gothic canopy that corresponds to the Gothic tracery and shape of the window itself.

32

You that are Israelites, listen to what I have to say: Jesus of Nazareth, a man attested to you by God with deeds of power, wonders, and signs that God did through him among you, as you yourselves know – this man, handed over to you according to the definite plan and foreknowledge of God, you crucified and killed by the hands of those outside the law. But God raised him up, having freed him from death, because it was impossible for him to be held in its power."

" 'Fellow Israelites, I may say to you confidently of our ancestor David that he both died and was buried, and his tomb is with us to this day. Since he was a prophet, he knew that God had sworn with an oath to him that he would put one of his descendants on his throne. Foreseeing this, David spoke of the resurrection of the Messiah, saying,

> 'He was not abandoned to Hades,
> nor did his flesh experience corruption.'

This Jesus God raised up, and of that all of us are witnesses. Being therefore exalted at the right hand of God, and having received from the Father the promise of the Holy Spirit, he has poured out this that you both see and hear. For David did not ascend into the heavens, but he himself says,

> 'The Lord said to my Lord,
> Sit at my right hand,
> until I make your enemies your footstool.' "

Installed between 1892 and 1905. After the fire of 1891 it took 14 years to rebuild the chancel. The Tiffany Decorating Company was hired to rebuild it in similar Gothic style. The memorial was dedicated to the mother of George R. Sprague. There is no inscription on the window but it replaced one lost in the fire. The rebuilding of the chancel and replacement of the window was paid for by both insurance and church fund raising. The robes of Christ are an example of drapery glass.

St Luke's Episcopal Church, Scranton ❖ *Acts:2:22-24; 29-35* ❖ *The Ascension*

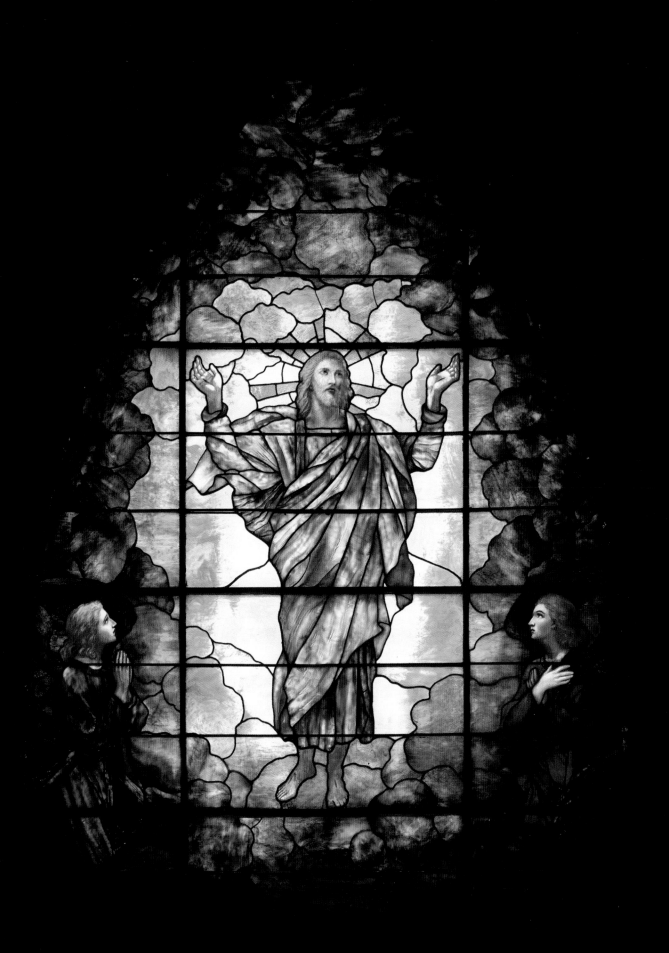

33

in those days a decree went out from Emperor Augustus that all the world should be registered. This was the first registration and was taken while Quirinius was governor of Syria. All went to their own towns to be registered. Joseph also went from the town of Nazareth in Galilee to Judea, to the city of David called Bethlehem, because he was descended from the house and family of David. He went to be registered with Mary, to whom he was engaged and who was expecting a child. While they were there, the time came for her to deliver her child. And she gave birth to her firstborn son and wrapped him in bands of cloth, and laid him in a manger, because there was no place for them in the inn."

"In that region there were shepherds living in the fields, keeping watch over their flocks by night. Then an angel of the Lord stood before them, and the glory of the Lord shone around them, and they were terrified. But the angel said to them, 'Do not be afraid; for see – I am bringing you good news of great joy for all the people: to you is born this day in the city of David a Savior, who is the Messiah, the Lord. This will be a sign for you: you will find a child wrapped in bands of cloth and lying in a manger.' And suddenly there was with the angel a multitude of the heavenly host, praising God and saying,

> 'Glory to God in the highest heaven,
> and on earth peace among those
> whom he favors!' "

"When the Angels had left them and gone into heaven, the shepherds said to one another, 'Let us go now to Bethlehem and see this thing that has taken place, which the Lord has made known to us.' So they went with haste and found Mary and Joseph, and a child lying in the manger. When they saw this, they made known what had been told them about this child; and all who heard it were amazed at what the shepherds told them. But Mary treasured all these words and pondered them in her heart. The shepherds returned, glorifying and praising God for all they had heard and seen, as it had been told them."

Signature: Tiffany Studios, New York. Installed in 1910, according to church information. A memorial "In Abiding Memory of Lydia Merrill Poore, Wife of George L. Dickson and their children John M. Dickson – A.D – 1910 Harriet L Dickson." The cityscape in the background is similar to the one in window four in Covenant Presbyterian Church.

St Luke's Episcopal Church, Scranton ❖ *Luke 2: 1-20* ❖ *The Nativity*

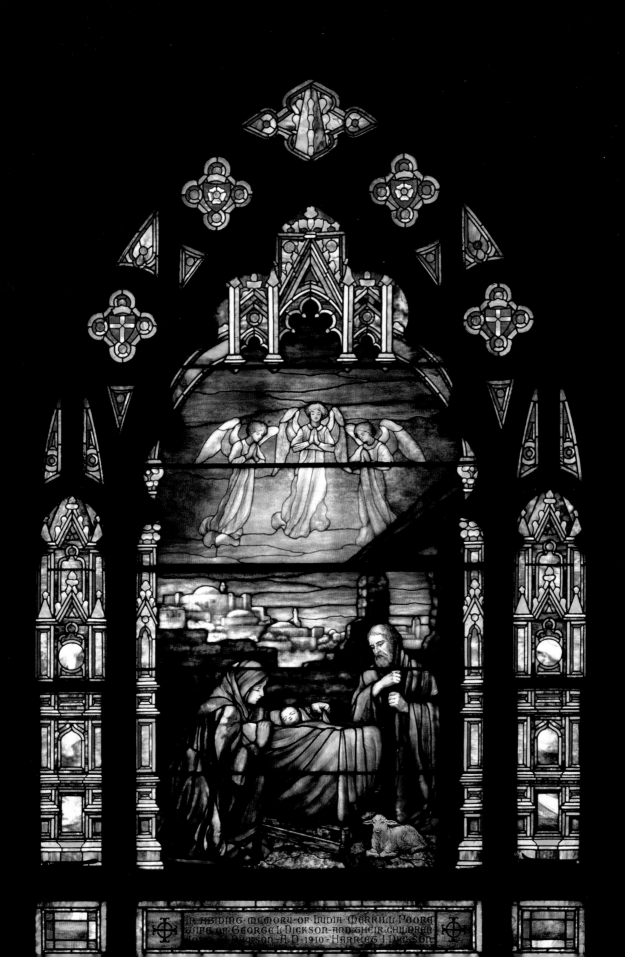

IN ABIDING MEMORY OF LYDIA MERRILL POORE
WIFE OF GEORGE L DICKSON AND THEIR CHILDREN
DICKSON A D 1910 HARRIET J DICKSON

St. Peter's Cathedral

The Cathedral of St. Peter, designed by the Scranton architect Joel Amsden, was built in 1865 and originally dedicated to St. Vincent de Paul (who is featured in one of the cathedral windows). It became the Cathedral of the Diocese of Scranton in 1868. Between 1883 and 1884 the church was renovated. The original brick Greek-Revival style was modified by the Philadelphia architect Edwin Forrest Durang to what was termed a "Second Empire style" (Beaux-Arts). The towers were extended to several levels and now dominate the city's skyline. Additional doorways were added to the nave. The interior was completely frescoed, with decorative enhancement of the arches that support the flat ceiling, and faux marble effects for the Corinthian columns and pilasters. Above the

altar there is a monumental painting of the *Crucifixion* and between the patterned windows at the sides are large painted figures of the Apostles. The figurative windows were added only in the 20th century.

The extant list of commissions kept by Franz Mayer & Company of Munich, Germany, notes that the St. Peter's Cathedral received a "set" of windows between 1929 and 1934 (to coincide with the Jubilee Renovations of 1934). The studio lists also note a set of nine windows made for the Bishop's chapel in the rectory building next to the cathedral, installed in 1929-1931. The signature in the Cathedral's *Visitation* window, as well as one of the windows in the Rectory's chancel, "F. Mayer, Munich/New York," corroborate the documentation. Though the company had a New York office, all the windows were fabricated in Munich, Germany. The addition of these windows was apparently coordinated with an "interior facelifting" that included the painting of the seven sacraments on the ceiling and the placing of the *Transfiguration* of Raphael over the main altar. These windows include the *Annunciation*, the *Visitation*, *Nativity*, and *Last Supper*. In the sanctuary there are windows of *St. Patrick*, *St. Vincent de Paul*, and *Christ Revealing his Sacred Heart to St. Margaret Mary Alacoque*. In keeping with the classical inspiration of the cathedral's interior, the style of the windows shows similar classical influence. The figures are three-dimensional and done with the impressive draftsmanship that characterized this Munich studio. The frames of the windows, the moldings, and the decorative architectural foliage are done in Baroque style. Small angels in three-dimensional form hold up inscription panels in the window base. The striking use of silver stain in the borders of the windows and their deep gold colors set against the white walls increases the impression of richness.

34

Patrick, the Apostle of Ireland (389-461), was born in Roman Britain. Seized by Irish raiders and sold as a slave in Ireland, he escaped after six years and returned to Britain. There he was changed by a conversion experience and began to preach the Christian faith to the Irish. He then went back to the Continent to be trained as a priest. Because of his lack of education, however, he did not get back to Ireland until after the death of Bishop Palladius, whom Pope Celestine I had sent there in 431. Patrick was soon appointed as his successor. He traveled mainly in western and northern Ireland where Christianity had not yet been preached. He attracted the support of local kings and made many converts. Since Ireland had no towns as were found in Roman Britain, he established episcopal churches with quasi-monastic chapters. Throughout his life he had to face many dangers, especially from the Druids. They represented the ancient religious traditions of Ireland.

The most accurate information we have about Saint Patrick comes from his writings in the *Confessio*, an account of his spiritual development and the importance of his mission. It is above all a homage to God, both for the gifts given to him despite his unworthiness and for his care of the people of Ireland.

The cult of St. Patrick dates from the sixth century. It soon spread to France, Italy, and Germany. The coming of the Anglo-Normans to England increased devotion there to St. Patrick and other Irish saints. When St. Patrick's supposed relics were deposited in Down Cathedral in 1186, an English Cistercian named Jocelyn of Furness wrote a life of St. Patrick which became the basis for all succeeding lives. The stories about St. Patrick's expulsion of all poisonous snakes from the island, as well as using the shamrock as a way of teaching the Trinity, are considered legendary developments.

> *Extant lists of commissions by Frank Mayer Studio, Munich, Germany note a "set" of windows done for St. Peter's Cathedral. This window also has the same angel figures as those at the bottom of window 36, which is a signed Mayer. It is located in the front of the church at the left, nearest the altar and reads: "St. Patrick Teaching at Tara."*

St Peter's Cathedral, Scranton ❖ *St Patrick Preaching at Tara*

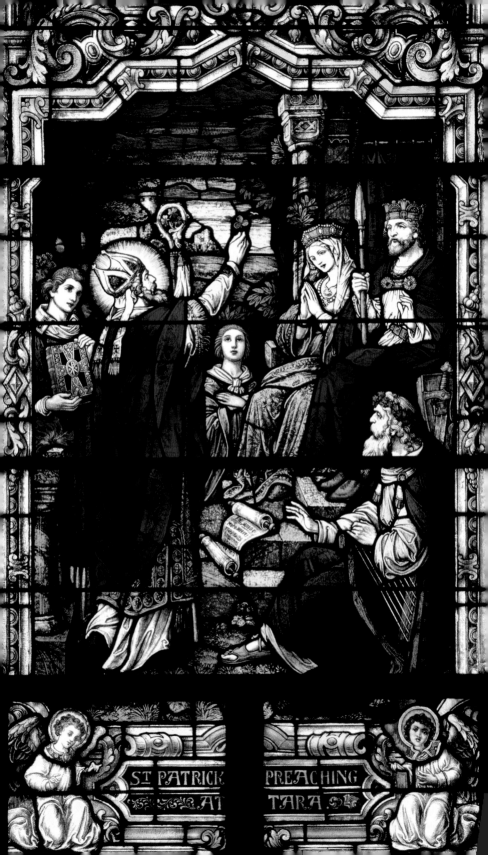

ST PATRICK PREACHING AT TARA.

35

i n the sixth month the angel Gabriel was sent by God to a town in Galilee called Nazareth, to a virgin engaged to a man whose name was Joseph, of the house of David. The virgin's name was Mary. And he came to her and said, 'Greetings, favored one! The Lord is with you.' But she was much perplexed by his words and pondered what sort of greetings this might be. The angel said to her, 'Do not be afraid, Mary, for you have found favor with God. And now, you will conceive in your womb and bear a son, and you will name him Jesus. He will be great, and will be called the Son of the Most High, and the Lord God will give to him the throne of his ancestor David. He will reign over the house of Jacob forever, and of his kingdom there will be no end.' Mary said to the angel, 'How can this be, since I am a virgin?' The angel said to her, 'The Holy Spirit will come upon you, and the power of the Most High will overshadow you; therefore the child to be born will be holy; he will be called Son of God. And now, your relative Elizabeth in her old age has also conceived a son; and this is the sixth month for her who was said to be barren. For nothing will be impossible with God.' Then Mary said, 'Here am I, the servant of the Lord; let it be with me according to your word.' Then the angel departed from her."

Fabricated by Mayer, of Munich, the window was probably installed between 1929 and 1934. The inscription reads, "Hail Mary Full of Grace. The Lord is With Thee." (Luke 1:28, Douay Bible). The window is located on the left side of the church along with various Mayer windows.

St Peter's Cathedral, Scranton ❖ *Luke: 1:26-38* ❖ *The Annunciation*

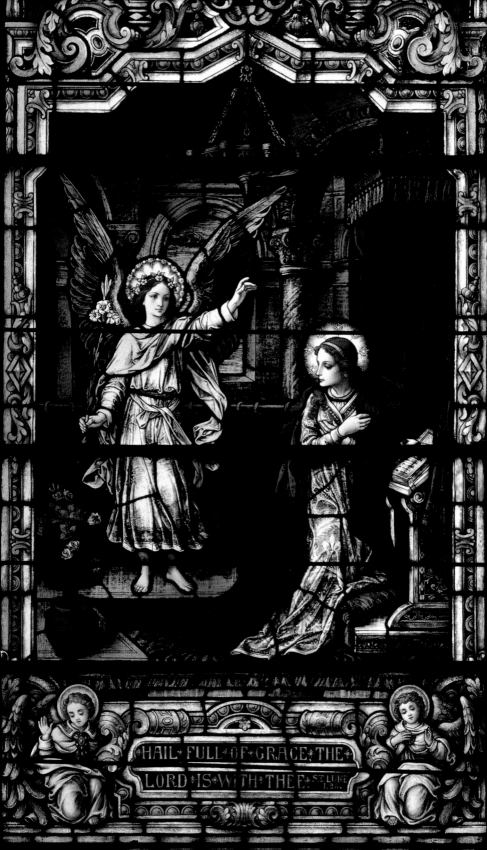

HAIL FULL OF GRACE THE
LORD IS WITH THEE St LUKE

36

in those days Mary set out and went with haste to a Judean town in the hill country, where she entered the house of Zechariah and greeted Elizabeth. When Elizabeth heard Mary's greeting, the child leaped in her womb. And Elizabeth was filled with the Holy Spirit and exclaimed with a loud cry, 'Blessed are you among women, and blessed is the fruit of your womb. And why has this happened to me, that the mother of my Lord comes to me? For as soon as I heard the sound of your greeting, the child in my womb leaped for joy. And blessed is she who believed that there would be a fulfillment of what was spoken to her by the Lord.' "

"And Mary said, 'My soul magnifies the Lord,
and my spirit rejoices in God my Savior,
For he has looked with favor on the lowliness of his servant.
Surely, from now on all generations will call
me blessed; for the Mighty One has done
great things for me, and holy is his name.
His mercy is for those who fear him
from generation to generation.
He has shown strength with his arm;
he has scattered the proud in the thoughts of their hearts.
He has brought down the powerful from their thrones,
and lifted up the lowly;
he has filled the hungry with good things,
and sent the rich away empty.
He has helped his servant Israel,
in remembrance of his mercy,
according to the promise he made to our ancestors,
to Abraham and to his descendants forever.' "

"And Mary remained with her about three months and then returned to her home."

Signature reads "Mayer and Company, Munich/New York." Window was installed between 1929 and 1934. The inscription reads "Blessed art thou among women." (Luke 1:42, Douay, Bible).

St Peter's Cathedral, Scranton ❖ Luke 1:39-56 ❖ The Visitation

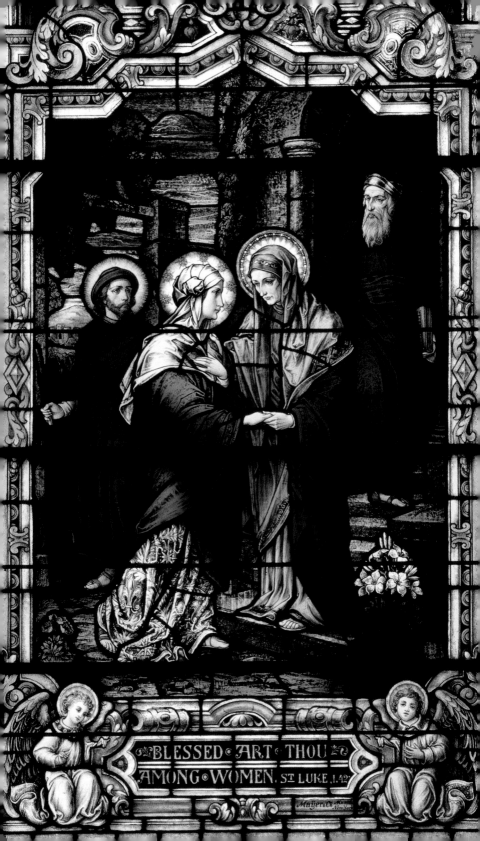

BLESSED ART THOU
AMONG WOMEN. ST LUKE I. 42

St. Peter's Cathedral Rectory Chapel

37

Among the Apostles, St. Thomas was a figure to be taken into account. He challenges his fellow Apostles at one point that they should be ready to die with Jesus (John 11:16). It is his firm questioning that leads to Jesus' famous phrase, "I am the way, and the truth, and the life" (John 14:6). He is best known, however, for his skepticism in the face of Jesus' resurrection. He would not believe his companions when they said that he had "seen the Lord." He goes even further and says that the only way he will believe is if he can put his fingers into the wounds of Jesus in his chest and hands. But when Jesus appears once again to his disciples in the upper chamber and asks Thomas to touch his wounds, the "doubting Thomas" snaps to attention and says "My Lord and my God" (John 20-28). There is little information about Thomas the Apostle after Pentecost. But there is the interesting phenomenon, that when Portuguese explorers landed in southeast India in the 16th century, they found a Christian community that claimed to have been founded by Thomas. And that community has flourished and grown to this day.

Both Thomas windows, though installed at a later period, are related to the fact that in 1888, the Diocese of Scranton founded a small Catholic college and called it St. Thomas College. The search for truth, sometimes expressed as "doubt" is admirably symbolized by Thomas the Apostle.

Designed and signed by Mayer Studios of Munich, Germany.
Installed sometime between 1929 and 1931 in the Oratory of the Little Flower
(unofficially called the Bishop's Chapel) in the Cathedral Rectory, Scranton, PA.
The inscription reads "St. Thomas the Apostle."

St Peter's Cathedral Rectory Chapel, Scranton ❖ *St. Thomas the Apostle*

ST•THOMAS APOSTLE•

38

Born into a noble family, Thomas was educated at the Benedictine school at Monte Cassino. Over family opposition, he joined the Dominican order in 1244. From 1245 to 1248 he studied in Paris under the famous St. Albertus Magnus and was later sent to Italy where he taught in Dominican schools. He went back to Paris in 1269. It was while he was working in Naples to set up a Dominican School that he was summoned to the Council of Lyons in 1274 and died on the way.

He is, of course, remembered for the number and importance of his writings. He wrote extensive commentaries on the writings of the Greek philosopher Aristotle and used a number of his ideas as tools for pursuing Christian theology. He also wrote biblical commentaries which contain a great deal of theology. The high points of his work, of course, are his two "Summae," the *Summa Contra Gentiles* and the *Summa Theologiae*. This last is generally considered to be the high point of medieval Christian systematic thought, even though at his death it remained unfinished. Despite some controversy from a local bishop, his teachings were accepted by the Catholic Church as a foundation for theological method and thinking.

Made a Doctor of the Church and called the "Angelic Doctor," his theology was virtually canonized by the Catholic Church in the 19th century. Though this "Thomism" is less influential in the 21st century, it still remains an important guidepost for Christian thinkers. Along with St. Thomas the Apostle, then, St. Thomas Aquinas is a fitting symbol and model for the small 19th century diocesan college which grew into the Jesuit University of Scranton.

Designed by Mayer Studios of Munich, Germany. Installed some time between 1929 and 1931 in the Oratory of the Little Flower (unofficially called the Bishop's Chapel) in the Cathedral Rectory, Scranton, PA. The inscription reads, "St Thomas Aquinas." The single building, now torn down, called "Old South," which housed the original St Thomas College, abutted the Rectory and Chapel.

St Peter's Cathedral Rectory Chapel, Scranton ❖ *St. Thomas Aquinas (1225-1274)*

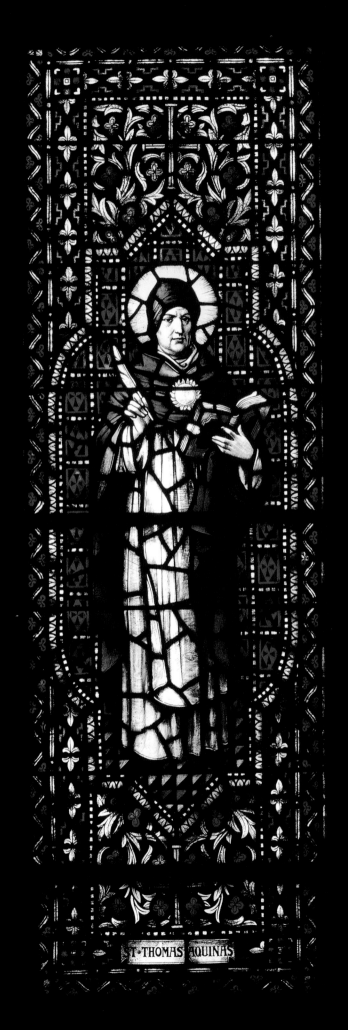

ST·THOMAS AQUINAS

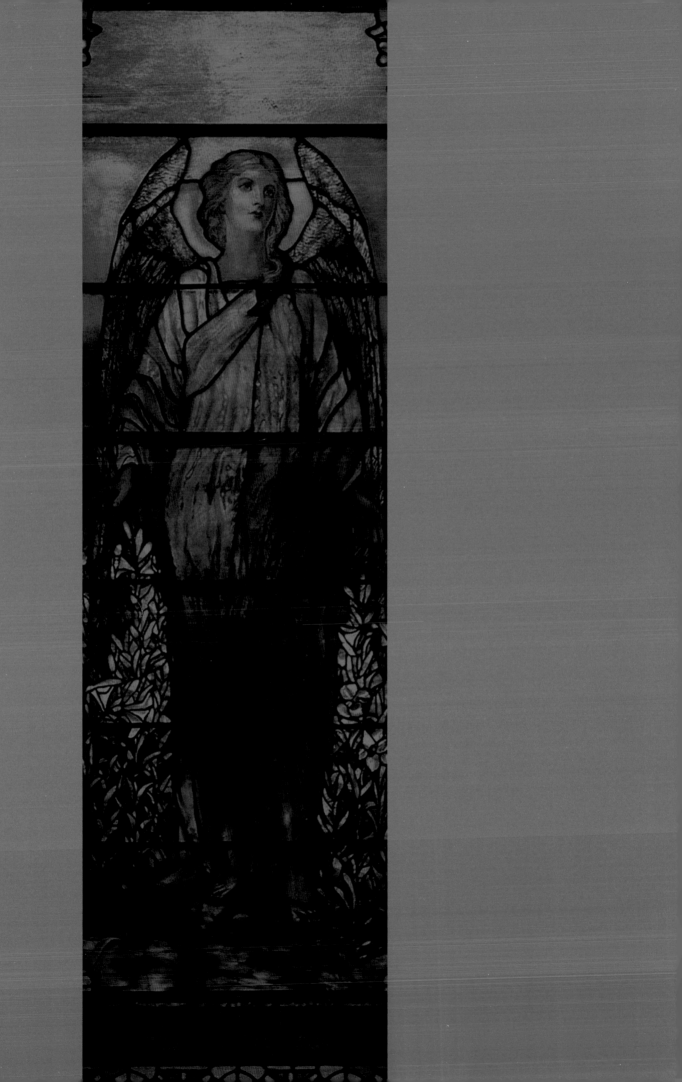

Trinity Episcopal Church

Trinity Episcopal Church, Carbondale, was built between 1899 and 1901 according to the plans of the architect Henry M. Congdon and Son, New York. The congregation was established in 1832, and its first services were held in the homes of its members, followed by a building shared with the Methodists. It was a wooden building and was moved later when the stone church was built. The present church is constructed in a rural Gothic style, with a distinct nave, transept, and chancel, all with high-pitched roofs. A low, square tower abuts the entrance to the left. These forms and the warm, brown stone of the construction hearken back to English country churches of the 13th century.

The interior is graced with a considerable number of impressive stained glass windows. The John S. Law family gave a window showing the *Angel*

of the Resurrection. The window is in three sections. The central lancet, considerably larger, frames the image of an angel set against a lush floral background and blue sky. A multi-tiered Gothic canopy, inspired by 14th century models, glows with opalescent colors. Smaller canopies are atop the lancets at the side. Below each window are Gothic quatrefoils. In the side windows, designed in a vertical lattice format, there are shields inscribed with Alpha and Omega, the beginning and end of the Greek alphabet. This refers to Christ's promise in the *Book of Revelation* where John is shown "a new heaven and a new earth." Christ proclaims "See I am making all things new . . . I am the Alpha and the Omega, the beginning and the end." (Revelations 21: 1, 5-6).

Though some have identified the woman in the window as St. Agnes, a young girl in the city of Rome, executed at the age of 13 or 14, whose attribute is a lamb, it more likely represents a figure popular at the time the windows was created, namely a woman "contemplating" the mysteries of life. In many churches, donors were offered wide latitude in selecting the subject matter of the windows. The work is in typical Tiffany Studios style. It presents a generic, non-denominational image, one that evokes personal and traditional reactions. The landscape evokes the passages of the psalms such as "to lie down beside quiet waters." The woman is dressed in a vaguely classical dress; her hand is on a bench that might even be an altar. The lamb evokes the virtues of meekness and humility as well as the memory of the Good Shepherd. "I know my sheep and they know me." She reads from an open book, symbolizing both intellectual and spiritual activity. In this way, the woman's family and friends try to honor her as a virtuous person.

39

in the New Testament angels carried out the same kinds of missions as the angels found in the Old Testament. An angel, for example, says to Zechariah, "I am Gabriel. I stand in the presence of God, and I have been sent to speak to you . . ." (Luke: 1:19). And "In the sixth month the angel Gabriel was sent by God to a town in Galilee called Nazareth, to a virgin engaged to a man whose name was Joseph, of the house of David. The virgin's name was Mary" (Luke: 1:26–27). "And in that region they were shepherds living in the fields, keeping watch over their flocks by night. Then an Angel of the Lord stood before them and the glory of the Lord shone around them and they were terrified. But the angel said to them, 'Do not be afraid' " (Luke 2:8-10). At the *Resurrection*, "an angel of the Lord, descending from heaven, came and rolled back the stone and sat on it. His appearance was like lightning and his clothing white as snow." (Matthew: 28:2-3). At the moment of the *Ascension* of Jesus, the apostles were "gazing up toward heaven, suddenly two men in white robes stood by them. They said, 'Men of Galilee, why do you stand looking up toward heaven? This Jesus, who has been taken up from you into heaven, will come in the same way as you saw him go into heaven' " (Acts 1:10–11). And finally, the angels are the ones who present the prayers of the just to God, "Another angel with a golden censer came and stood at the altar; he was given a great quantity of incense to offer with the prayers of all the saints on the golden altar that is before the throne" (Revelation: 8:3).

Signed: Tiffany Studios, New York. Installation between 1899-1901.
A memorial to the John S. Law Family.

Trinity Episcopal Church, Carbondale ❖ *Angel of Resurrection*

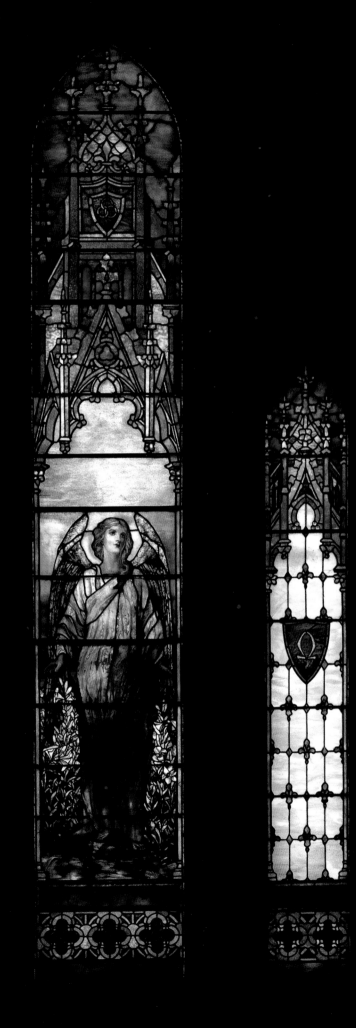

40

Though some have identified this woman in the window as St. Agnes, a young Christian girl of the city of Rome, executed at the age of 13 or 14, whose attribute is a lamb, it is more likely a representation of a popular figure at the time that the window was created and placed in the church, namely, a woman "contemplating" the mysteries of life and death. It is this second interpretation that seems current among present church members.

Attributed to the Tiffany Studios where this "contemplative" theme was popular at the time, which was probably shortly after 1911. A memorial "In Loving Memory of Euphemia Simpson Hubbard (1861-1911)." Erected by her husband and son.

Trinity Episcopal Church, Carbondale ❖ *Contemplative Figure*

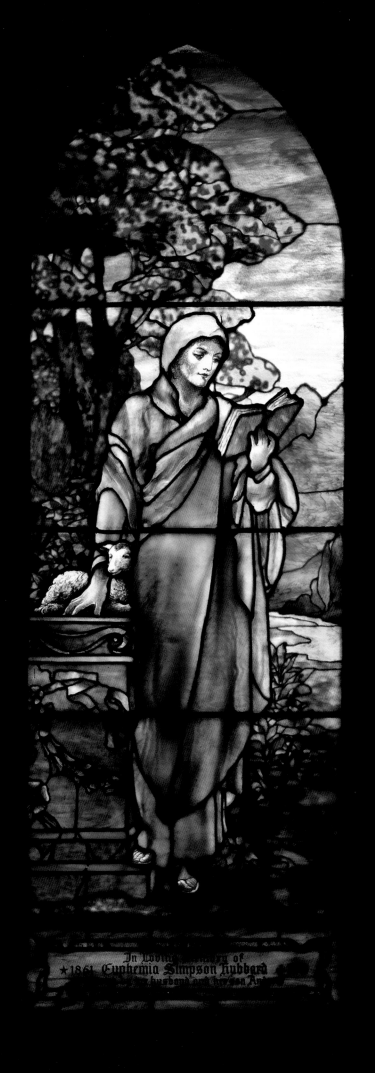

In Loving Memory of
★ 1861 Euphemia Simpson Hubbard
husband and their son An

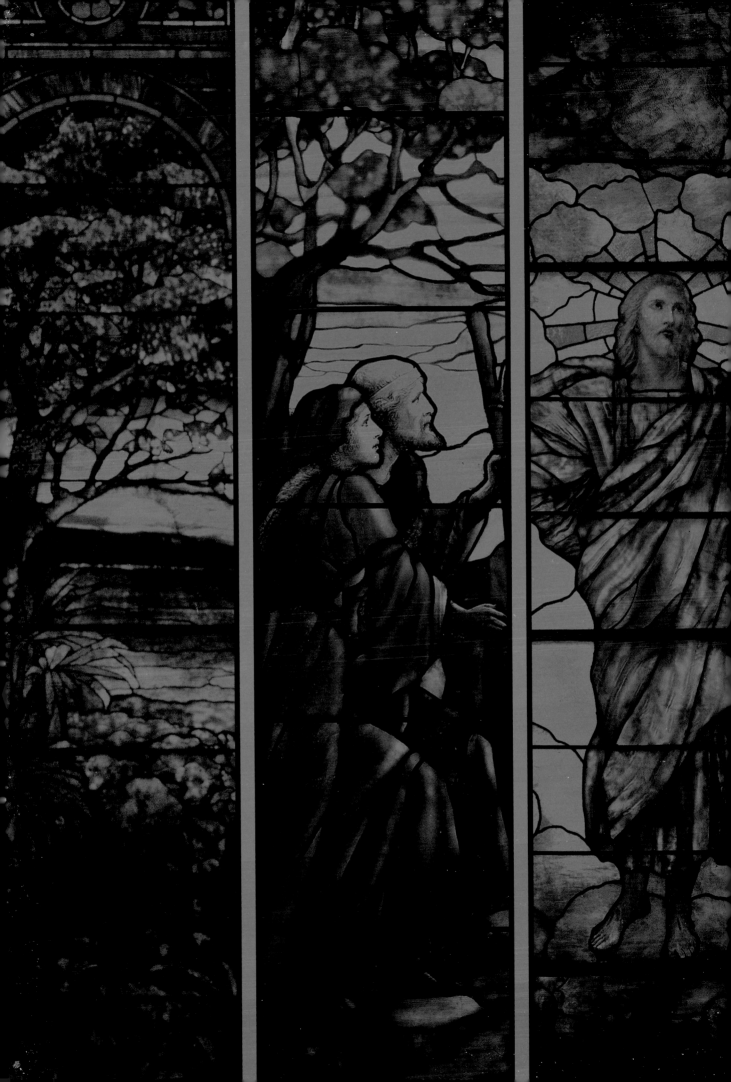